Eric Ravilious

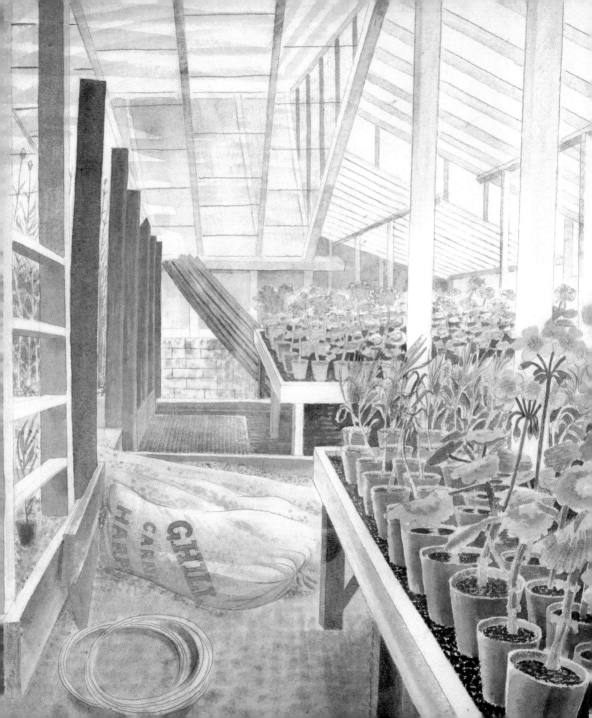

Eric Ravilious

LANDSCAPES & NATURE

Ella Ravilious

Thames &Hudson | V&A

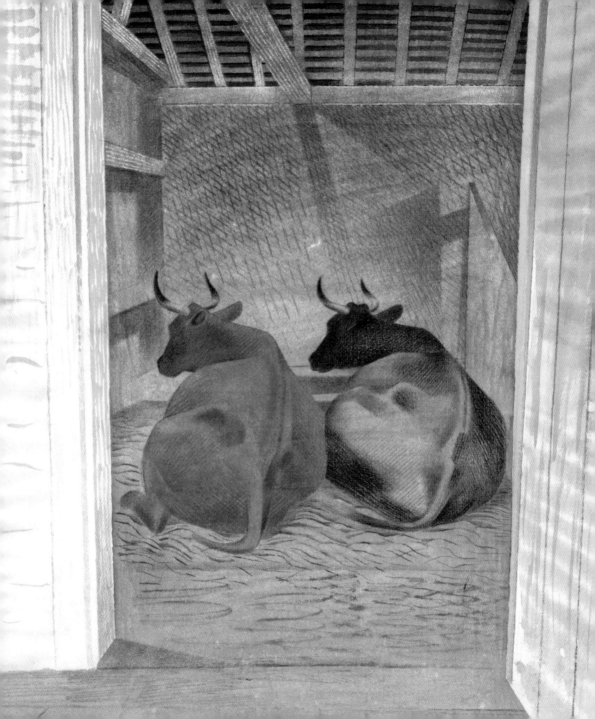

Contents

6 Preface
8 Introduction
34 Plates

140 Notes
142 Picture Credits
142 Acknowledgments
143 Selected Bibliography
143 Author's Biography

Preface

In September 1922 an 18-year-old student at the Royal College of Art in London wandered down the staircase from the college workshops, opened a side door and found himself standing in the Victoria and Albert Museum. This young artist was my grandfather Eric Ravilious, and what he found among the treasures of the V&A was to inspire the rest of his short but prolific career as an artist and designer.

Eric Ravilious's sensibility for weather and landscape would make him well known as a particularly 'English' artist. His relationship with natural elements took many forms, and this book is organized to explore those themes: weather, plants and gardens, animals, landscapes, and the human presence in nature. This allows exploration of the motifs to which he returned throughout his career, from aeroplanes, lighthouses, greenhouses and derelict vehicles to chalk figures, stars, fireworks, picnics, teapots, umbrellas and watering cans. Ravilious avoided the accepted canon of subjects for landscape paintings, often including 'unpicturesque' elements. Although his works are now often viewed with nostalgia, at the time they were made, showing a cement factory or a biplane in a painting of the English landscape was startlingly modern – akin to an electric car or a wind turbine appearing in a landscape painting today. Ravilious welcomed such inclusions, and consequently his works express no disapproval of modernity.

After his death Ravilious was initially hard to place for posterity. The revival of his artistic reputation began with his

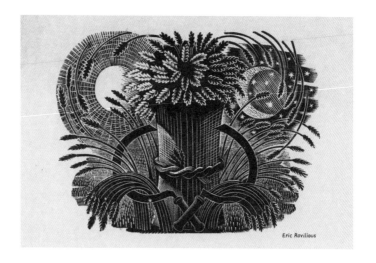

Fig. 1 Detail of illustration to the
John Murray autumn catalogue, 1937,
showing a motif first created for the
Cornhill Magazine in 1933
Wood engraving
Private collection

watercolours but has expanded to include his contribution to
design and illustration. More recently, writers and curators have
brought him to a wider audience, and the publication of his letters
and the diary of his wife, Tirzah Garwood, have brought his life
and character into focus. His sensibility for nature has left a rec-
ognizable body of work that conveys a particular moment of life
and landscape in early twentieth-century Britain.

 This book is dedicated to Anne Ullmann, daughter of Eric
Ravilious and Tirzah Garwood.

Introduction

'I've just finished a new drawing – ... a drawing began in a hurry because of this glorious weather and so all the colours of the rainbow – and I'm not sure whether it is good or very bad.'[1]

Eric Ravilious was born in 1903 in Acton, west London, where his parents, Frank and Emma Ravilious, ran a draper's shop. Emma, who had been in domestic service before her marriage, was a kind and practical person. Frank had trained as a coachbuilder, but after a stay in hospital had become deeply and idiosyncratically religious. He formed his own vision of Christianity and developed personal interpretations of biblical prophesies. Tirzah Garwood (1908–1951) later recalled her father-in-law writing 'God is Love' in his hatband and carving the same message into marrows in his garden with a penknife. Such preoccupations left him with little attention for business, and soon after Eric's birth his father declared himself bankrupt. In 1907 the family sold up and moved to Eastbourne on the south coast of England, where they kept a series of failing shops, including a draper's and an antiques shop, suffering further monetary and legal problems. Ravilious remembered, 'There was so often a financial crisis looming over us all in Eastbourne that we began to expect them as a matter of course.'[2]

These childhood experiences appear to have rendered Ravilious a staunch atheist and prompted in him a certain emotional detachment. A close friend, Helen Binyon (1904–1979), recounts: 'There [in Eastbourne] Ravilious spent a happy childhood; he seems to have been able to abstract himself in spirit from the emotional pressures coming from his father's religious obsessions and from the intermittent difficulties about money – a talent that was noticed by his companions in later life.'[3] He probably

Fig. 2 Eric Ravilious aged 23, *c.*1926, probably photographed by Phyllis Dodd (1899–1995) in Redcliffe Road, Earls Court, London
Photograph
Private collection

8

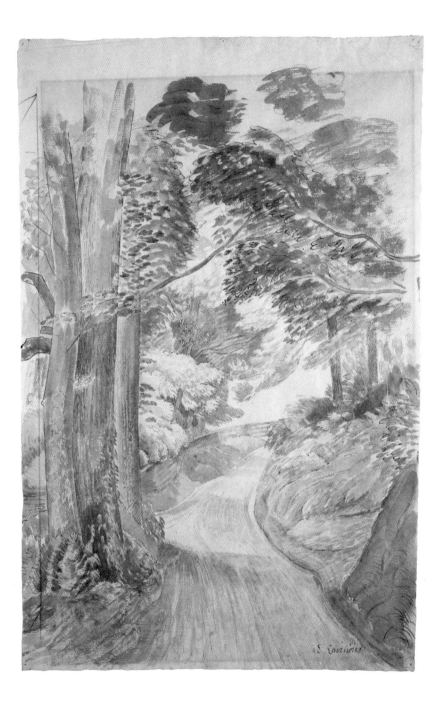

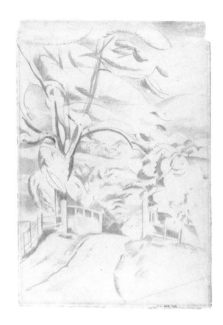

Fig. 3 *East Dean Road, Sussex, c.*1927
Pen, ink and watercolour
Whitworth Art Gallery, Manchester
(D.1938.3)

Fig. 4 Paul Nash (1889–1946),
The Edge of the Lake, 1923
Pencil drawing
Victoria and Albert Museum, London
(V&A: CIRC.404–1962)

developed his love of aircraft during these early years, since the Eastbourne Flying School was based nearby on the Willingdon levels, and from 1913 the Eastbourne Aviation Company ran a factory making biplanes on the Crumbles shingle beach.

Ravilious studied at the local grammar school and won a scholarship to Eastbourne School of Art in 1919. There, in the summer term, he began to sketch in the countryside, even sleeping out on the Sussex Downs with student friends. After one of the appointed students dropped out, Ravilious, as runner-up, was awarded a scholarship to the Royal College of Art (RCA) in London in 1922. At that time the Principal, William Rothenstein, interviewed selected students and chose on their behalf which discipline they would train in. Ravilious was assigned to the Design School to specialize in book illustration, rather than the more prestigious Painting School, so he obediently turned his thoughts towards becoming a designer and illustrator.

The RCA then occupied the complex of buildings that also held the V&A, and students were encouraged to spend time in the galleries, and particularly in the National Art Library, where Ravilious spent many hours looking at historic books, prints and watercolours to develop his knowledge.

An 'outbreak of talent' is how Paul Nash (fig. 4), who taught Ravilious at the Design School, later referred to this era, and the young Eric certainly had exciting company. Artists such as Douglas Percy Bliss (1900–1984), Enid Marx (1902–1998), Edward Burra (1905–1976), Barbara Hepworth (1903–1975) and Henry Moore (1898–1986) were all fellow students during this period, and he got to know many of them well. Ravilious soon became close friends with fellow design student Edward Bawden (1903–1989). Nicknamed 'Rav' or 'The Boy' by his friends, Eric threw himself into the social life of the RCA, chatting in the Student Common Room and going to dances.

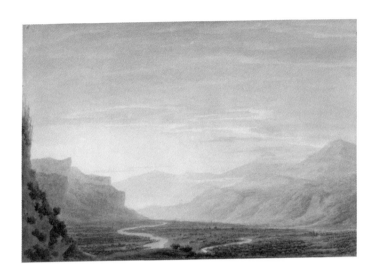

Nash proved a key influence in Ravilious's development as both an artist and a designer. As well as providing technical advice, his own creative output opened up new possibilities for Ravilious and his circle. Nash promoted an interest in wood engraving, then a rather neglected art form. He encouraged Ravilious to try this medium and introduced him to publishers who might use his work. Ravilious created the cover illustration for the RCA Student Magazine *Gallimaufry* in 1925 (**41**), and in 1926, after Nash had successfully proposed Ravilious's membership to the Society of Wood Engravers, the young artist was approached by the publishing house Jonathan Cape and awarded his first proper commission. This was to illustrate the novel *Desert: A Legend* by Martin Armstrong (**79, 87**), and one can see Nash's influence clearly in the engravings Ravilious produced for the book. It was, however, a salutary experience as far as Ravilious was concerned; he was disappointed in the quality of the printing and felt that much of the delicacy of his engravings had been lost in the printing process. He subsequently modified his technique to suit the

Fig. 5 John Robert Cozens (1752–1797),
Valley with Winding Streams, 1774
Watercolour
Victoria and Albert Museum, London
(V&A: DYCE.708)

INTRODUCTION

production methods used in publishing. This was to stand him in good stead in his next work, at the Golden Cockerel Press with the artist Robert Gibbings (1889–1958), whom he had met through the Society of Wood Engravers (33–6, 60, 93). Gibbings had recently bought this small private press and would publish 72 books during his nine-year ownership. Under its previous owner, Noel Rooke, and then Gibbings, the Golden Cockerel Press revived the use of wood engraving in book illustration in the 1920s and 1930s. Ravilious had tried working in watercolour in Eastbourne (fig. 3), but with Nash as an example and the rich collections of the V&A and the British Museum as inspiration, he also began to explore this medium more seriously.

In London Ravilious was able to examine many more works by the artists he admired, among them John Robert Cozens (fig. 5), Thomas Girtin (fig. 7), John Sell Cotman (1782–1842) and particularly Francis Towne (fig. 16) and Samuel Palmer (fig. 6). Palmer's work was almost unknown at the time and just beginning to be rediscovered. Ravilious observed the way artists could develop

Fig. 6 Samuel Palmer (1805–1881), *The Bellman*, 1879, printed 1926
Etching
Victoria and Albert Museum, London
(V&A: E.1464-1926)
Presented by A.H. Palmer, Esq.

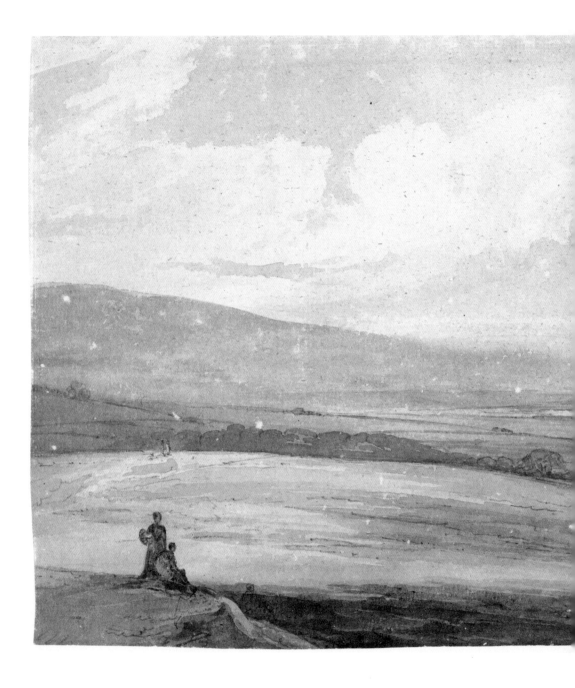

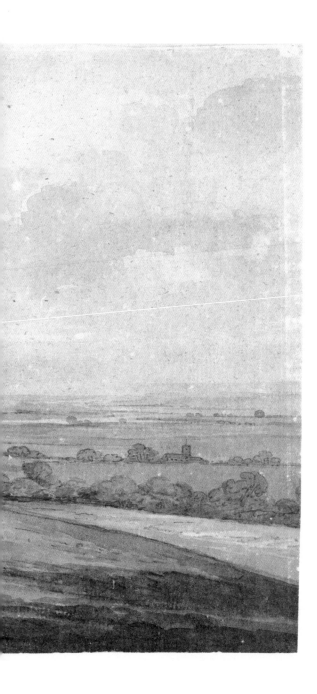

Fig. 7 Thomas Girtin (1775–1802),
Landscape with Hermit, 1801
Watercolour
Victoria and Albert Museum, London
(V&A: Dyce.723)

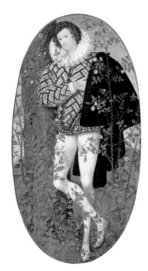

Fig. 8 Page from one of Ravilious's
scrapbooks with drawings of costume
and dress seen at the V&A, including
Nicholas Hilliard's miniature *Young
Man among Roses*, bottom right
Pencil on paper
Fry Art Gallery, Saffron Walden
(2198)

Fig. 9 Nicholas Hilliard (1547–1619),
Young Man among Roses, *c.*1587
Watercolour on vellum
Victoria and Albert Museum, London
(V&A: P.163–1910)
Bequeathed by George Salting

a relationship with a landscape or region that inspired them, as
Palmer had in Shoreham, Kent, and Nash had with Wittenham
Clumps in the Thames Valley. Ravilious was profoundly inspired
by the V&A's exhibition in 1926 of Palmer's work, which brought
his output to a wider audience for the first time. He responded
to Palmer's mix of deeply rooted mystical archetypes and local
landscape settings, and he even visited Shoreham, where Palmer
had lived and worked.

Ravilious's explorations of London museums went further
than watercolourists and printmakers. He also drew from cos-
tumes, furniture and ceramics in the collections of the V&A, as
his scrapbooks show. In their book on Ravilious's scrapbooks,
Peyton Skipwith and Brian Webb note that his collaged pages of
sketches include objects in the V&A's collection, such as dresses
and miniatures (figs. 8, 9).[4] His friend Douglas Percy Bliss recalled
that Ravilious:

was educating himself, finding in the indigestible super-abundance of the great city's art the particular nourishment he needed. He was fastidious and assimilative, culling his fruits from any bough, trying out conventions from Gothic tapestries, Elizabethan painted-cloths, the wood-cuts of Incunabula, or Persian miniatures ... In the great dish of Art confronting us at South Kensington, like Mrs Todgers [a character in Charles Dickens's novel *Martin Chuzzlewit*], he 'dodged about among the tender pieces with a fork'.[5]

Ravilious continued to use the British Museum and the V&A as sources of inspiration, mentioning in letters throughout his career how he made visits in order to research the elements he needed for his commissions. After his graduation in 1925, Ravilious's income from wood engravings was supplemented by a part-time teaching job at Eastbourne School of Art. He was a stimulating teacher, according to accounts by his former pupils, and took them out every summer by bus or bicycle for sketching expeditions on the Sussex Downs. During his second year of teaching he fell in love with a student newly enrolled at the art school. Her name was Tirzah Garwood; she was 18. The daughter of a colonel, Garwood was of a different social class from Ravilious, and this caused tension in the courtship, particularly between the young couple and Garwood's parents. Colonel Garwood initially disapproved of Ravilious and deliberately mispronounced his surname in protest – in his diary he records that 'Ramvillas', 'Reveillious', 'Ravilliers', and many other variations, came to court his daughter.[6] Tirzah's diary recalls her first impression of Ravilious:

He had a smart double-breasted suit and shy, diffident manners not unlike those of a curate and, with my family's training behind me, I quickly spotted that he wasn't quite a gentleman and as he took no particular notice

of me, [he was] conceived as well. He was tall and thin with a small head that jutted out at the back, his eyes were large, light-brown or hazel coloured with long girlish lashes which gave him an appealing look, so that motherly women often offered him cups of tea. This look was only superficial, he wasn't really at all effeminate nor did he need sympathy, but it was true he was inordinately fond of tea.[7]

In 1928 a major commission was to land in Ravilious's path after graduate students of the RCA were invited to submit designs for murals at Morley College for Working Men and Women in Lambeth, south London. Both Ravilious and his friend Bawden were successful in their applications, and for the following two years they each worked on transferring their designs to their assigned halves of the refreshment room. Part of Ravilious's design depicted an open doll's house, showing the interior and inhabitants of a lodging house (23). Bawden described Ravilious's mural as including 'Elizabethan plays, Shakespeare, Olympian gods and goddesses, Punch and Judy, a Miracle Play and a doll's house – Gosh! what a riot it was … The love affair with Tirzah Garwood blossomed on one of the walls; Tirzah impersonating Venus, fully in the nude, stood proudly on a floating cloud.'[8] In a letter describing the mural, Ravilious wrote:

I don't know quite how to describe the doll's house next: it begins as a section of Redcliffe Road [the street in Earls Court, London, where Ravilious first lived in cheap accommodation during his student years], with more or less the kind of people who live opposite, but since then some of my friends have come into it, also quantities of furniture from home and elsewhere. I have imprisoned a mandrake in the yard under the green-house. A chicory root suggested the idea.[9]

Ravilious and Garwood were married in 1930 and settled in west London, first in Kensington, then in Hammersmith, where Ravilious took keen enjoyment in the yearly Oxford and Cambridge boat race on the River Thames, which was visible from their garden. He gave up his teaching job at Eastbourne, instead picking up teaching work at the Ruskin School of Art in Oxford and at his own former school, the RCA. He routinely took student groups around the V&A to point out particular objects and to encourage them to look at as many different things as possible. The art historian Sir John Rothenstein, William Rothenstein's son, recalled his friendly acquaintance with his father's pupil: 'He [Ravilious] was warm and candid, discussing works of art he had seen on his frequent visits to the Victoria and Albert Museum, certain departments of which he might already have been serving as a professional guide, such was the range of his knowledge.'[10]

Despite his passion for the cultural assets of the city, Ravilious longed to do more landscape painting and yearned for a permanent base in the countryside. He and Bawden took trips by train and bicycle to find somewhere suitably inspiring, with the idea that the two young couples – for Bawden had by this point met his future wife, fellow artist Charlotte Epton (1902–1970) – could make the move affordable by sharing a rented property within weekly commuting distance of their jobs in London. Together they found Brick House, a Georgian building in the rural Essex village of Great Bardfield. In 1931 they rented half the property, sharing the rest with their landlord, a retired ocean-liner stewardess. As Malcolm Yorke explains, 'The pretty but tamed countryside of north-west Essex seemed ideal, both artists being temperamentally wary of the peaks, chasms, torrents and forests of the wilder landscapes of Britain.'[11]

At Brick House, both the young couples' creativity and enjoyment of interior design were allowed free rein (fig. 10). Garwood and Ravilious enjoyed hunting for inspiring second-hand objects in junk shops and making their own household decor. When

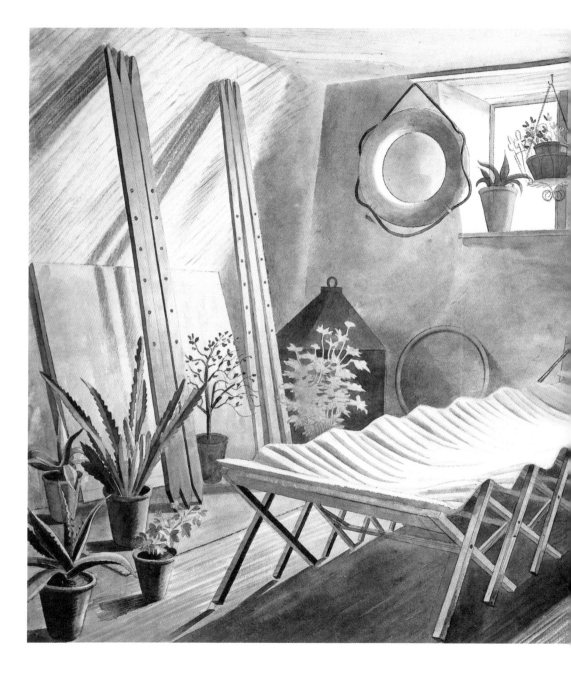

Fig. 10 *The Attic Bedroom, Brick House,*
Great Bardfield, 1931–3
Watercolour
Fry Art Gallery, Saffron Walden
(25)

their friend, the painter and designer Peggy Angus (1904–1993), visited, she was bowled over by the decorative invention that abounded throughout the house. Binyon writes: 'There were lozenges of marbled papers, repeated as patchwork patterns in the hall and passage; the dining-room had a wallpaper of rubbings from brasses, the parlour made her feel she was in a cane structure, with bird cages and birds everywhere, and a bedroom had become a striped tent, draped up to a centre point.'[12] In his book *Ravilious & Co: The Pattern of Friendship* (2018), Andy Friend describes the ethos of the Raviliouses and their circle, most of whom were in their late twenties or early thirties: 'Whatever their personal proclivities for a puritanical lifestyle (Bawden and [Thomas] Hennell) or for engaging with the left-wing politics of the 1930s (Angus, Binyon and [Percy] Horton), the collective mood of the group was one of liberty and hedonism both in life and [in] art, a release from the oppressive weight of growing up during the First World War.'[13]

Garwood developed her own artistic career as a wood engraver and paper marbler, as well as acting as a perceptive advisor and partner in Ravilious's work. She frequently did the more prosaic background cutting for his wood engravings, assisted with painting sections of his murals, and modelled for him. After his death she became a collagist and painter. A photograph documents her painting sections of Ravilious's mural for the tearoom and bar of the newly built Art Deco-styled Midland Railway Hotel in Morecambe, Lancashire (fig. 11), a prestigious commission that came their way in 1933 after the success of the Morley College mural. The Morecambe mural depicted fanciful seaside piers and jetties with a display of flags and fireworks over the ocean.

In 1934 the Raviliouses moved from Brick House into their own rented property, Bank House, in nearby Castle Hedingham. Their first child, John, was born there the following year. But their marriage was under strain owing to Ravilious's affair with Helen Binyon, an RCA graduate whom he knew from his student days. More and more, Ravilious was drawn to the chalk landscape of

Fig. 11 Tirzah Garwood and Eric Ravilious painting the Midland Hotel mural, 1933
Photograph
Private collection

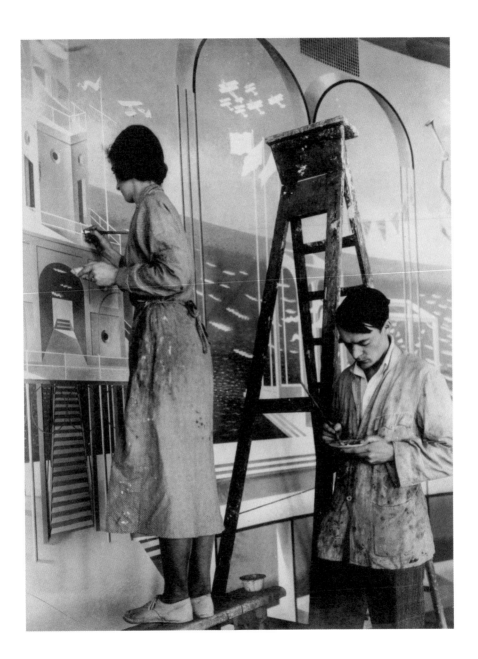

the South Downs, and Garwood recalled that he 'complained of the unpleasant colour of the Essex earth and he wanted to escape having to paint continually the vivid green of grass which seemed to be present in any possible local subjects.'[14] As a consequence, Ravilious paid many visits to Peggy Angus's house, Furlongs (**97**), on the South Downs, as a place both to paint and to rendezvous with Binyon. In the gentle hills, chalk and dewponds he found the colours and shapes he had been looking for, and his watercolour work flourished. He later wrote to Angus gratefully to say that Furlongs had altered his whole outlook and way of painting.

Angus's strong spiritual and political views and commitment to 'art for all' made Furlongs a formative place for many artists. A passionate socialist, she befriended local people and encouraged mixing between these friends and the artistic circles in which she also moved. Her husband, the architectural writer James Maude Richards (1907–1992), later wrote of Ravilious, 'His feeling for the Sussex landscape, especially that of the chalk downs behind Eastbourne, with their bony outlines clothed in tawny grass shimmering in the wind, never left him, and his distinctive, dry, precise but evocative watercolour style evolved as part of the process of portraying it.'[15]

Having been part of the Design School rather than the Painting School at the RCA, Ravilious was at first apprehensive about calling himself an artist. Garwood found that he 'had an inferiority complex because he was a designer and it took years to get rid of this feeling … Eric aimed modestly at being a good second-rate painter and engraver.'[16] Indeed, he was so modest that he 'queered the market' with his low prices.[17] His close friendship with Bawden, who was also from a shopkeeping background, perhaps helped them both to gain the confidence to find their way as artists.

As he developed his distinctive watercolour technique in the chalk landscape of Sussex, Ravilious's self-assurance grew. The historian Alan Powers describes his process:

He worked on relatively thin and smooth paper, always to approximately the same size, and right up to the edge of the sheet … Ravilious became extremely skilled at working areas of shadow to give a variety of colours in an apparently smooth blend. This would require a sixth sense, based on long experience, of when to work into a preceding wash just before it dried, although … Ravilious often wetted the paper from the back which would have kept the paint fluid but still controllable.[18]

This technique gave Ravilious the precision he desired and helped to avoid the muddiness of unsuccessful watercolour application when too many colours have blended. Indeed, Ravilious himself tore up four of every five watercolours out of dissatisfaction, although Garwood sometimes kept the pieces and later collaged them for her own amusement. Powers continues: 'His use of individual dry strokes and later of sponged or stippled effects, gives the impression that his paintings are built up like a confetti of small touches, but in fact they are much more subtle and unified in their underlayers, and the dry work tends to be on top of these.'[19] The requirement to let successive layers of watercolour dry completely before applying further paint meant that Ravilious often added colour from memory. The drawings were done on the spot and often annotated (fig. 12; **68**), but the painting was done back at home or in his lodgings. Speaking of both Bawden and Ravilious, Garwood later recounted, 'Their training as designers brought a liveliness and originality to their work, and they chose subjects of a documentary interest. In pursuit of these they competed with one another in working under conditions of various hardships, in ghastly weather, or with the sun bang in their eyes.'[20]

People in Ravilious's work can appear somewhat blank-faced and toy-like, conveying more through posture than through facial expression. Often they have their backs to the viewer, or their focus is averted by a task. Figures are frequently depicted

Fig. 12 Detail of *The Long Man of Wilmington*, 1939
Watercolour
Victoria and Albert Museum, London
(V&A: P.3–1940)

Enol papers E Ravilious.

playing roles, sometimes theatrically, as in his illustrations for an edition of William Shakespeare's *Twelfth Night* published by the Golden Cockerel Press in 1932, or professionally, as in his war work and in his book *High Street* (4, 63, 64, 65). In other works they represent gods or mythical creatures, as in his chalk figures and interpretations of the zodiac.

Watercolour increasingly became Ravilious's chosen medium, and he was invited to put on solo exhibitions of his paintings at the Zwemmer Gallery in London in 1933 and 1936. The gallery was owned by the Dutch bookseller and publisher Anton Zwemmer (1892–1979), who probably came across Ravilious through his book illustrations.

As an artist of slender means, Ravilious continued to undertake a prolific amount of commercial design work, often put his way by contacts from his RCA years. He designed bookplates, murals, endpapers (fig. 13), glassware, book covers, furniture and fabrics, often drawing on natural elements such as ferns and cacti to create repeating decorative motifs and original flourishes. Ravilious continued to draw inspiration from an eclectic range of sources, and, having spotted an object that sparked his interest in a friend's house or an antiques shop, he would dash off to the V&A for further research. Fellow designer Enid Marx remembered him making a trip to look at Staffordshire pottery, which inspired one of his best and most harmonious illustrations: his design in 1933 for the *Cornhill Magazine* (fig. 1), a literary journal owned by John Murray. He made several illustrations for this publication, all of which draw on themes of nature.

Ravilious and Garwood both made scrapbooks of their eclectic visual inspirations. Binyon noted that 'Eric found it very useful to have "scrap books" of all the odds and ends he felt might be worth keeping: first try-outs of designs and patterns, cuttings from newspapers, photographs, odd bits of information, working notes, tracings for engravings, anything that might be useful as possible reference, germs of ideas, or just records.'[21]

Fig. 13 Endpaper, not used but possibly designed for Martin Armstrong, *Desert: A Legend*, published by Jonathan Cape, 1926
Wood engraving
Victoria and Albert Museum, London
(V&A: E.535-1972)

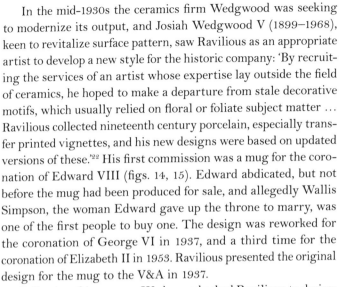

In the mid-1930s the ceramics firm Wedgwood was seeking to modernize its output, and Josiah Wedgwood V (1899–1968), keen to revitalize surface pattern, saw Ravilious as an appropriate artist to develop a new style for the historic company: 'By recruiting the services of an artist whose expertise lay outside the field of ceramics, he hoped to make a departure from stale decorative motifs, which usually relied on floral or foliate subject matter … Ravilious collected nineteenth century porcelain, especially transfer printed vignettes, and his new designs were based on updated versions of these.'[22] His first commission was a mug for the coronation of Edward VIII (figs. 14, 15). Edward abdicated, but not before the mug had been produced for sale, and allegedly Wallis Simpson, the woman Edward gave up the throne to marry, was one of the first people to buy one. The design was reworked for the coronation of George VI in 1937, and a third time for the coronation of Elizabeth II in 1953. Ravilious presented the original design for the mug to the V&A in 1937.

Following this success, Wedgwood asked Ravilious to design for the company for six weeks each year, with royalties based on sales. He reworked his existing designs and motifs for the task and created stylized natural patterns and vignettes, often in the bucolic tradition but with a modern twist, to suit the shapes Wedgwood presented. Richards later noted of his joyful and distinctive designs, 'Ravilious mugs and plates, like Ravilious engravings, were unmistakeably his and no-one else's.'[23]

Ravilious first experimented with lithography in his print for the Contemporary Lithographs series, *Newhaven Harbour* (6), and his print *The Grape House* (22) for the Curwen Press. He enjoyed the material challenges posed by lithography, a technique that involves drawing in wax crayon on limestone printing blocks. The complex process allowed easier mass production of colour-printed illustration, creating subtle overlays of colour with the soft, mottled lines typical of wax crayon. *High Street* (4, 63, 64, 65), a more intensive lithographic project, evolved out of an initial idea from

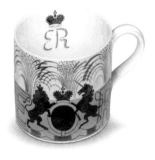

Fig. 14 Coronation mug, made by Josiah Wedgwood and Sons Ltd, Etruria, 1936
Glazed earthenware with printed design
Victoria and Albert Museum, London
(V&A: C.77-1971)
Bequeathed by Miss B.E. Chambers

INTRODUCTION

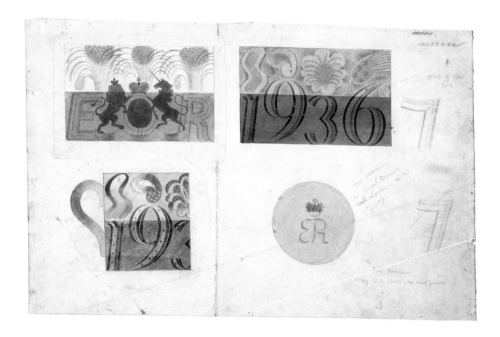

Fig. 15 Design for Coronation mug,
made for Josiah Wedgwood and
Sons Ltd, Etruria, 1936
Pencil and watercolour
Victoria and Albert Museum, London
(V&A: E.292–1937)
Given by Eric Ravilious

Binyon for Ravilious to make an alphabet of shops. The final book, as Gill Saunders has noted, was 'an idiosyncratic and in many ways personal project' for Ravilious the shopkeeper's son.[24] The volume celebrated local shops and specialist businesses, and Ravilious's lithographs were accompanied by text by his friend Richards.

Despite his successes, by the late 1930s Ravilious was restless and unsure of his artistic path. His affair with Binyon had ended, and in letters to friends he only half-jokingly expressed worries about how to navigate middle age as an artist. A solution arrived with World War II. He signed up for the Royal Observer Corps the day war broke out, and started work that very afternoon, watching out for enemy aircraft on the coast.

Ravilious enjoyed his new role. He painted pictures of the observation post and wrote that 'as far as wars go it is a congenial job, and the scene lovely, mushrooms about and blackberries

coming along and the most spectacular sunrises.'[25] He hoped, however, to become an official war artist, and enquired through friends and contacts whether a formal scheme might commence. After hearing nothing for some months, on Christmas Eve 1939 he received a letter from the Admiralty stating that he and John Nash (Paul's younger brother) were both offered commissions as official war artists with the rank of Honorary Captain in the Royal Marines. Ravilious was delighted. As Richards later explained, 'this gave him commitments and a purpose, and solved for the time being the problem of the direction his life should take next.'[26]

Ravilious's first commission was at the Royal Naval Barracks at Chatham, Kent, and from there he was moved to nearby Sheerness and Whitstable, then to Grimsby, Lincolnshire, and then to Norway. He adapted well to the task, and the War Office was generally pleased with the works he created, although he had to err on the side of more serious subjects; his eager desire to paint a picture of the Admiral's bicycle at Chatham, for example, was refused. The art critic Christopher Neve describes Ravilious as 'producing commissioned war pictures with an air of getting down on paper in his own language and primarily for his own enjoyment the things he liked best'.[27] Norway was particularly stimulating for Ravilious, and he wrote to Garwood that the 'seas of the arctic circle are the finest blue you can imagine, an intense cerulean and sometimes almost black.'[28] After a month's leave he went to Gosport on the south coast of England to draw life inside submarines, then to Newhaven and Eastbourne to paint coastal defences.

Meanwhile Garwood was bringing up their two young boys with little income to spare; their third child, Anne, was born in April 1941. The young family moved to Ironbridge Farm in Shalford, Essex, with an agreement that Ravilious would pay part of the rent in paintings. That winter Garwood was diagnosed with breast cancer and had the first of several operations. Throughout the war, conditions for her and the children were challenging. As well as having to cope with rationing, both Bank House and Ironbridge

Farm had few, if any, amenities, such as cooking ranges or heating, and in the winter the water pipes froze. The children were also repeatedly ill with measles and other childhood complaints.

Ravilious, however, was experiencing a burst of inspiration and artistic development. He found both the hardware of war and the increased opportunities for travel stimulating, and he delighted in mixing modern man-made elements with the landscapes and seascapes he found himself in. His watercolour style became increasingly free and expansive, and his deep excitement over new vistas and technology is tangible. It was essential that he worked quickly, since he could not get in the way of military activity or scheduling. He wrote from Portsmouth that 'I've just arrived at this place, which is almost overwhelming in size and variety. I feel like an earwig setting out to draw Buckingham Palace though actually I want to try Portland and Poole and some expeditions perhaps to sea. It is a lively coast just now.'[29] His technique of creating annotated pencil drawings on the spot, which he painted later, was well suited to such working conditions, and his notes can often be seen through the finished watercolour. Ravilious had loved planes from childhood and now had the chance to paint from them in flight. The sheer exhilaration he felt comes through in these works. He wrote to Garwood, 'It was more lovely than words can say flying over the moors and the coast today in an open plane, just floating on great curly clouds and perfectly still and cool – except for the propeller of course.'[30]

Ravilious's enjoyment of wartime ordnance and activity was singularly devoid of jingoistic national pride, instead celebrating the strangeness of these new shapes. Neve writes about this perceptively in *Unquiet Landscape* (1990):

> His familiar landscape was drawn again by Ravilious, the same country but now stiffened and darkened by war. The odd thing was that, because of his nature, he drew it

in exactly the same way as before. England was suddenly no longer a picnicking and bicycling place, but in his watercolours the war looks like an accident, like a harrow left in a field … his war landscapes [were] painted with cheery absorption from what was in front of him day by day.[31]

Amid debate about what constitutes 'Englishness', Ravilious is often summoned to represent an arcadia of gentle landscapes, garden picnics and aunts bicycling to church. What this reading overlooks is his love of modernity and machinery, and his interest in exploring beyond British shores. Although his first trip abroad, to Italy as a student in 1924, left him temporarily overawed and unable to work, once war afforded him the means to travel, he was thrilled by France, Norway and finally Iceland. He was particularly eager to experience mountainous and arctic landscapes, and saw his war artist post as the opportunity to reach them. He requested a posting to Iceland to attempt landscapes similar to those explored by Francis Towne (fig. 16), whose works he had so admired at the V&A. Garwood later recalled one of their last conversations. His request had been granted and he was cleared to travel very shortly after she had undergone an emergency mastectomy and, on medical advice, an abortion. She wrote:

The morning before he was due to leave, he got up early to make the breakfast and standing in front of the mirror putting on his tie, he said 'Shall I not go to Iceland?' I knew that he desperately wanted to go and so I said 'No, I shall be alright'. He seemed relieved at my answer and enthusiastically repeated all the familiar reasons for this expedition to what had almost become to him the promised land.[32]

Fig. 16 Francis Towne (1739/40–1816), *The Source of the Arveiron, with Mont Blanc in the Background,* 1781
Watercolour
Victoria and Albert Museum, London
(V&A: P.20–1921)

Ravilious duly left, and within days of his arrival in Iceland went out by plane on a search mission that never returned. He was 39 when he went missing in 1942.

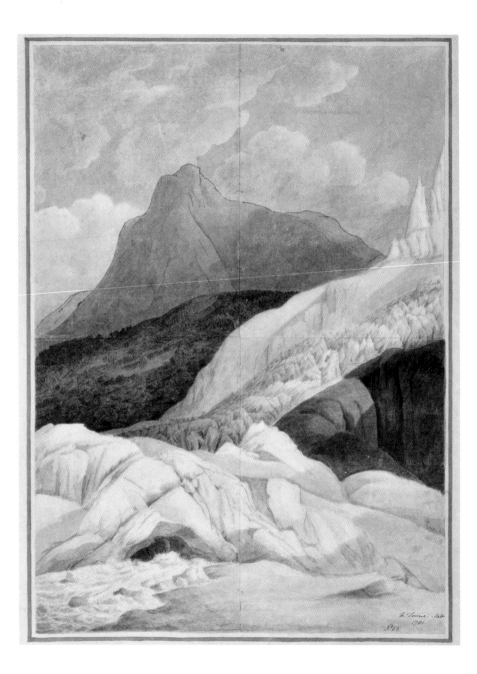

Plates

In this view of the church of St Mary in Capel-y-ffin, Powys, a figure trudges up the muddy Welsh lane in the drizzle, the leaves in the high, unevenly trimmed hedges glistening wet. The subtle range of browns and greens convincingly convey the light at the close of a short and soggy day. Ravilious wrote of his stay in Wales, 'The skies are superb but the hills so massive it is difficult to leave room for them on the paper.'[1]

1. *Wet Afternoon*, 1928
Watercolour
Private collection

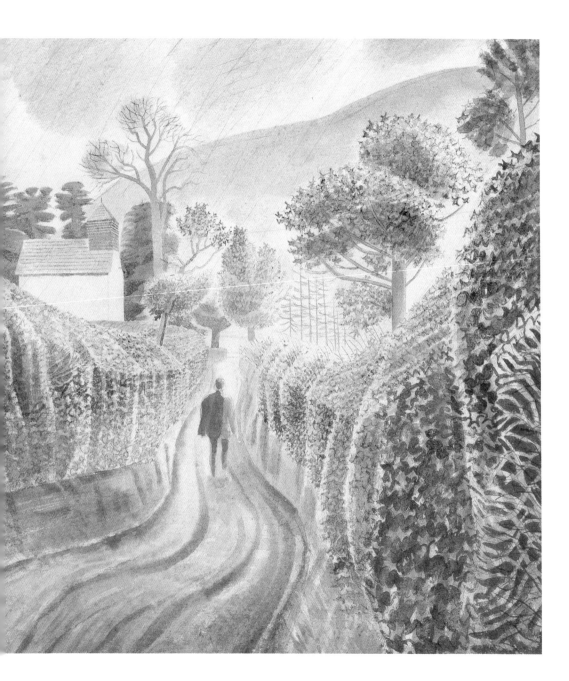

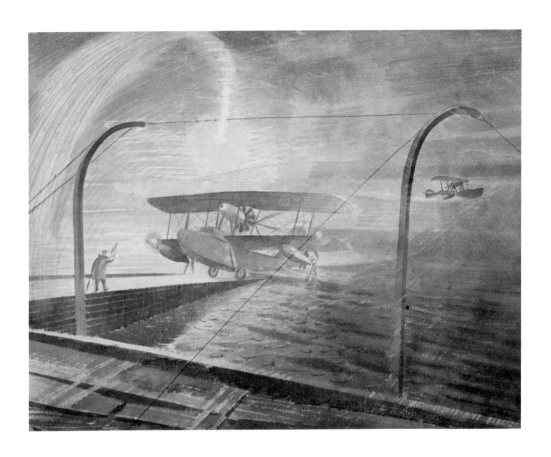

2. Night Operations, 1941
Watercolour
Birmingham Museum & Art Gallery
(1947P47)

Composed in Dundee during the winter of 1941 and executed
in pencil, watercolour and blue ink, this image painted
through a veil of rain appears to be dissolving into mist and
seawater. Ravilious was particularly enamoured of the Walrus
seaplanes: 'what I like about them is that they are comic things
with a strong personality like a duck, and designed to go slow.
You put your head out of the window and it is no more windy
than a train.'[2]

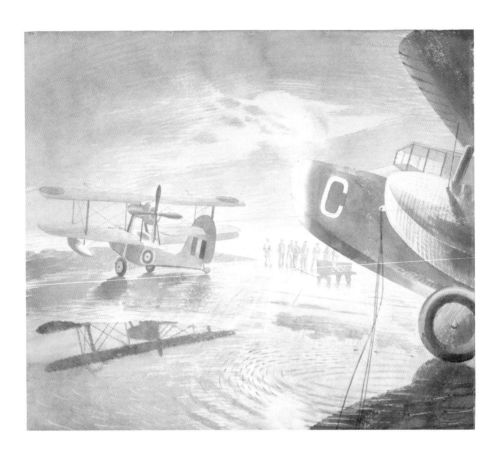

3. Morning on the Tarmac, 1941
Watercolour
Imperial War Museum
(Art.IWM ART LD 1712)

Painted during Ravilious's period as an official war artist, this airy watercolour is composed looking into the sun from under the shadow of an aircraft wing. Using only grey, yellow and blue, the artist has chosen to foreground the sunshine rippling in a puddle – the human activity is barely visible in the distance. The cross-hatched effects he developed in his watercolours allowed him to convey mottled skies and high cloud surpassingly well.

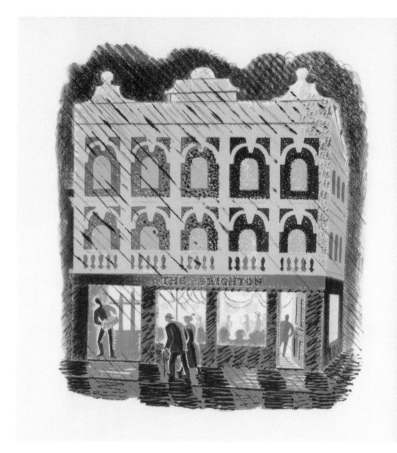

4. Illustration to J.M. Richards
and Eric Ravilious, *High Street*,
published by Curwen Press, 1938
Lithograph
Victoria and Albert Museum, London
(V&A NAL: 4025068)

An elderly couple march through the slanting rain, past the
inviting light and warmth from a traditional English Victorian
pub. Ravilious uses diagonal patterns to convey the downpour,
gloomy clouds and shiny streets, contrasted with jolly swags
and loops for the pub's architecture and decorations. The artist
John Piper (1903–1992) wrote of the illustrations in *High Street*
(**63, 64, 65**), 'There is about them the suggestion that you
are looking in at a series of gay, old-fashioned parties from
a matter-of-fact street in the present.'[3]

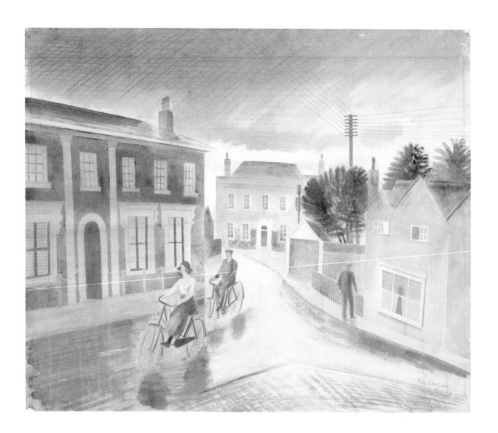

5. *Village Street*, 1936
Watercolour
Towner Eastbourne
(EASTGL 40)
On long loan

A man and woman cycle along, their shadows reflected in the wet road under a cross-hatch of looming rain and telephone wires. Years later Ravilious's daughter Anne spoke to a local in Castle Hedingham, Essex, who remembered Eric and identified the couple on the bicycles as 'Mr and Mrs Bennett-Smith who ran the ironmonger's shop in Falkener Square, where the ceiling was entirely hung with chamber pots which Eric loved. They cycled off for a picnic every week when they shut up shop for early closing.'[4]

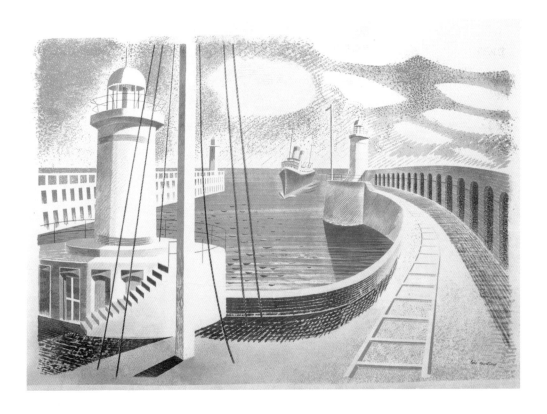

6. *Newhaven Harbour*, 1936
Lithograph
Victoria and Albert Museum, London
(V&A: CIRC.39–1937)

Designed specifically as affordable artwork for a wide audience, this sunny scene with its trim boat skating into harbour was one of Ravilious's first attempts at lithography. The effect of sunlight is so convincing that one is tempted to squint against the glare. Ravilious jokingly referred to this work as an homage to the late nineteenth-century French painter Georges Seurat (1859–1891), who was famous for his pointillist paintings. In Ravilious's mind, lithography gave a similar effect of small dots building up an image.

Ravilious made this engraving to illustrate a poem about
mortality. It demonstrates Edward Bawden's description of
Ravilious's work: 'Like [the eighteenth-century engraver]
Thomas Bewick he was a white line engraver. On the block
the design was not drawn in line or black ink, but merely as a
shaded pencil drawing that served only as a guide for the real
drawing that was done by the graver in the act of cutting into
the surface of the boxwood. Thus it is that Eric's engravings
have a freedom, liveliness and invention that have not been
equalled since the days of Bewick'.[5]

41

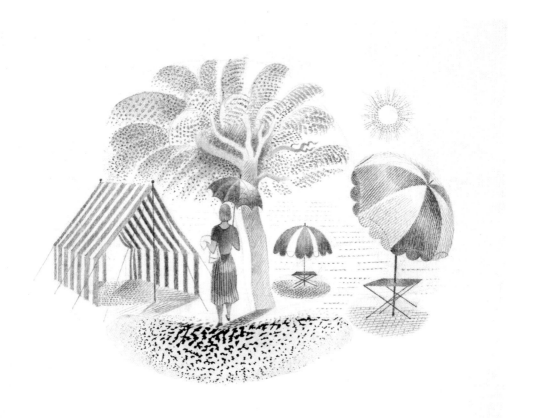

8. Design for a plate in the Garden
ceramics dinner service, made for Josiah
Wedgwood and Sons Ltd, Etruria, 1938
Watercolour
Towner Eastbourne
(EASTG 2354)

The Garden pattern was devised for a Wedgwood tableware
set (9). Ravilious makes the design lively by playing with solid
stripes on the figure's skirt and the tent, and strips of dots to
convey the background, sun rays and tree. Shadows in pale
yellow and green give the motif depth and a feeling of sunshine.
Cross-hatched lines imbue the nearer parasol with a convincing
roundness, to contrast with the geometric shapes of the
tent opposite.

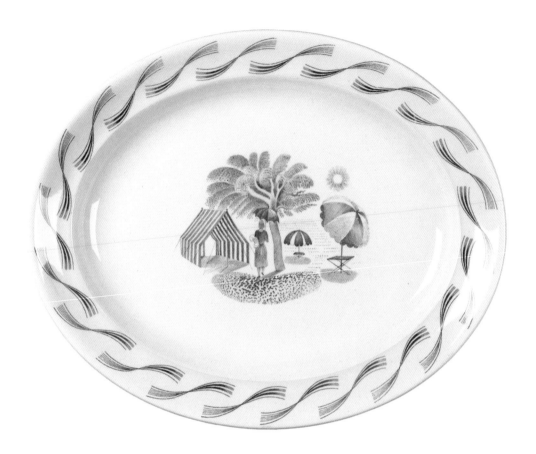

9. Meat platter in the Garden dinner
service, made by Josiah Wedgwood and
Sons Ltd, Etruria, 1938
Glazed earthenware with printed design
Victoria and Albert Museum, London
(V&A: CIRC.473–1948)

The finished platter shows how the design has been translated on to a piece of dinnerware. The colours have been strengthened and the lines made more distinct, yet the motif still seems calm and simple. Ravilious's scenes of gardens celebrate the vitality of nature and the joys of eating outdoors. This one, with its striped tent and parasols, invites the viewer to reminisce about sunny picnics, the pale colours almost creating the effect of a mirage.

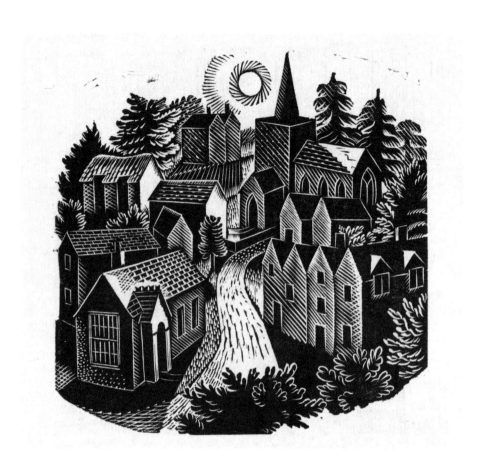

10. Cover proof to *The Village*,
a newsletter published by the
National Council of Social Service,
Great Britain, 1933
Wood engraving
Victoria and Albert Museum, London
(V&A: E.577–1972)

The brief for this engraving – designed for a newsletter
formerly called *The Village Hall* – was to celebrate civic
buildings and rural communities. The winding parade of sunlit
dwellings presided over by the church suggests an idealized
English parish laid out like a model village, inviting the viewer
into the scene. Ravilious's mark-making gives the effect of
bright sunlight on the trees and roofs.

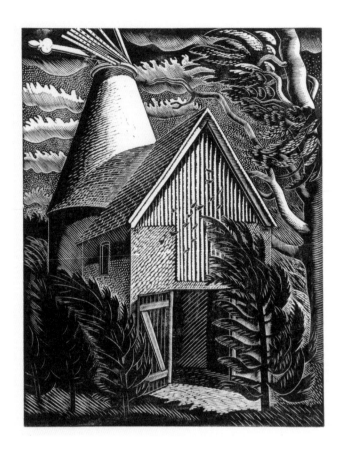

11. *The Windstorm*, 1931
Wood engraving
Museums Sheffield
(VIS.1698)

This lively engraving shows an oast house, a traditional building typical of Sussex and Kent in which hops are dried for brewing. The conical roof is topped with a cowl, which turns with the breeze to ventilate the hops below. Ravilious chose to depict the scene in a high wind: the buffeted clouds, trees and cowl all bear witness to the weather conditions.

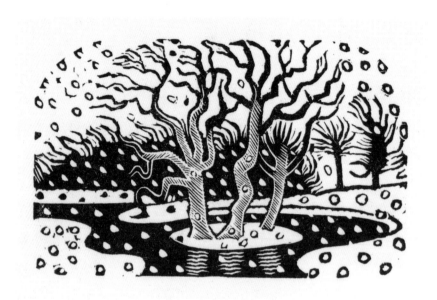

12. Illustration to *The Kynoch Press
Notebook*, 1932
Wood engraving
Private collection

One of Ravilious's best-known wood engravings, this simple
snow scene shows his pleasure in the technique. Carving the
woodblock required thinking in reverse in order to remove
some areas to show white while leaving others to show black,
to convey a layer of snowflakes falling across the whole scene.

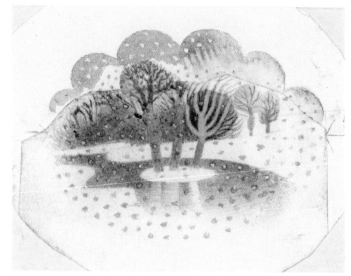

13. Entrance of the Royal Horticultural
Society Gardens, South Kensington,
London, c.1908
Photograph
Victoria and Albert Museum, London
(V&A: PH.756–1908)

14. Design for Travel ceramics, made
for Josiah Wedgwood and Sons Ltd,
Etruria, 1938
Watercolour
V&A Wedgwood Collection, Barlaston
(V&A Wedgwood Collection Archive:
WoP 4675)

Here Ravilious conjures another snowy scene of a tree-lined
pond, this time executed in greys and purples ready for
transfer on to Wedgwood's Travel tableware. The curvy top
edge to the design was a distinctive feature used throughout
the Travel set; it enlivened the central motifs and helped them
to harmonize with the pattern around the rim. Ravilious may
have been inspired to use this shape by the frontage of the
Royal Horticultural Society Gardens opposite the V&A on
Exhibition Road (13).

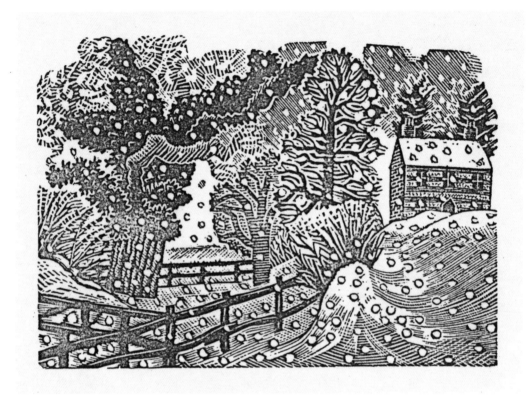

15. Proof print of a Christmas card, 1938
Wood engraving
Victoria and Albert Museum, London
(V&A: E.817–2019)
Bequeathed by Dr Lindsay Newman

Garwood and Ravilious's circle of friends often sent one another home-made Christmas cards. This one reuses a block Ravilious had already carved for another project: *Winter Snow*, originally made to illustrate *The Writings of Gilbert White of Selborne.*
This proof print has been poorly inked and is clearly a trial copy. Proofing in printmaking can mean making preliminary prints to ensure the artist and client are happy with the finished piece, or it can refer to the artist experimenting with inking the block to get the impression they want.

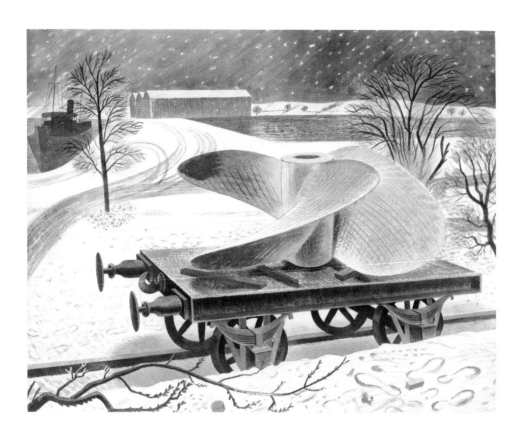

16. *Ship's Screw on a Railway Track*, 1940
Watercolour
Ashmolean Museum, Oxford
(WA1947.411)

Behind every snowy watercolour was a very cold and stoic artist. Ravilious – who said he rather enjoyed persevering through 'mild hardships'[6] – records wearing two overcoats and two waistcoats at once to paint, and thanked his friends for their gifts of warm clothing. He would have found this sculptural ship's propeller on a railway flat wagon irresistible as a subject. The sense of depth in this watercolour makes it easy to overlook the fact that he has achieved it using a restricted palette of colours: just black, white, blue and yellow.

More white paper than paint, this airy sketch almost seems
to disappear off the page. Ravilious captures his view from
a banking plane in an apparent vortex of clouds, sharing his
excitement at being airborne in such a fragile construction
of struts and propellers. Christopher Neve writes, 'The wing
stays and struts on a Tiger Moth were a gift to him, especially
when he could juggle with them in relation to woolly puffs
of cumulo-nimbus below.'[7]

17. *View from the Cockpit of a Moth*, 1942
Watercolour
Whitworth Art Gallery, Manchester
(D.1947.45)

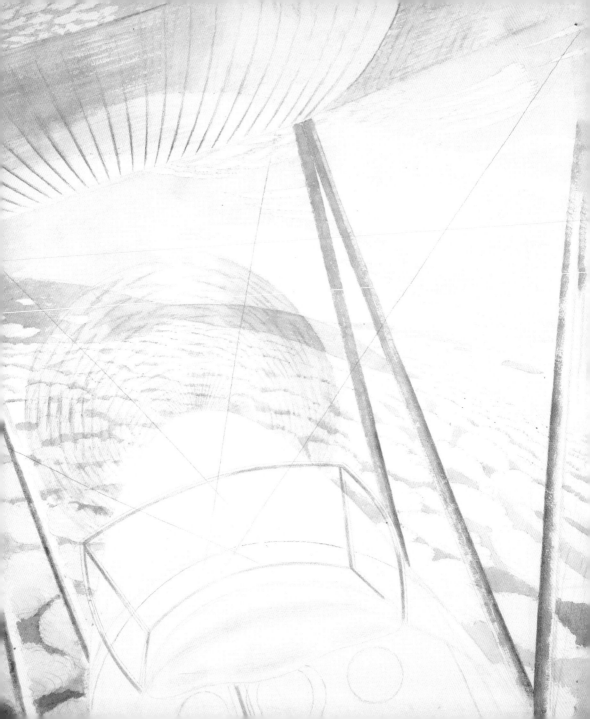

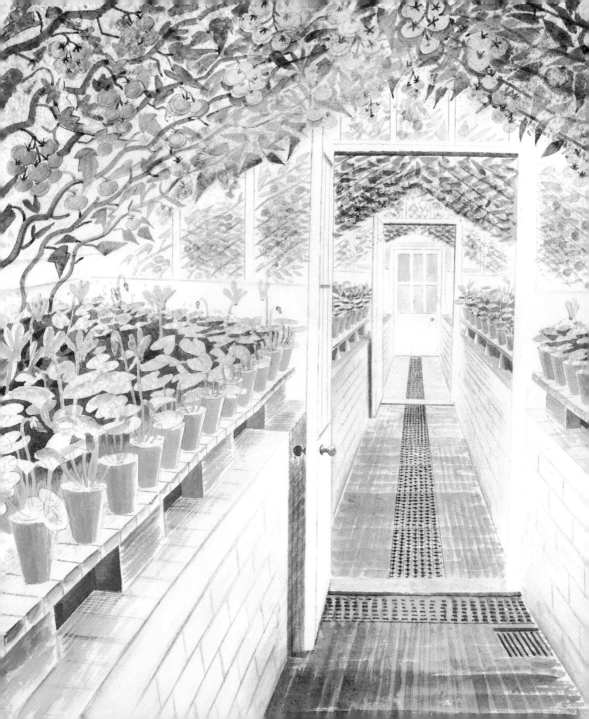

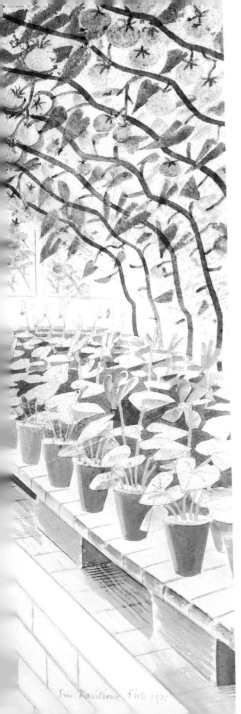

One of Ravilious's best-known subjects, greenhouses embody his love of manufactured structures intermingled with nature. This iron construction was painted in an elderly gardener's nursery garden at Firle in East Sussex. The combination of natural forms and man-made geometry in such spaces held a particular joy for Ravilious. Practically, they were also pleasant spaces in which to paint, and appealed to his love of open frameworks, from birdcages to pergolas.

18. *The Greenhouse: Cyclamen and Tomatoes*, 1935
Watercolour
Tate, London
(N05402)

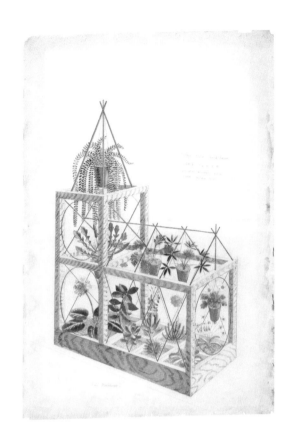

19. *Design for a Plant House*, for
the exhibition *Room and Book*,
Zwemmer Gallery, London, 1932
Watercolour
Private collection

Full of the cacti and succulents that were in vogue in the 1930s
just as they are today, this delightful design for a plant house is
a fanciful cross between a greenhouse and a church. This was
Ravilious's single entry to the influential exhibition *Room and
Book*, organized by Paul Nash in 1932, which celebrated new
artists working with interior design and furnishings. Ravilious
and Garwood took up the trend for such plants, and they crop
up in many of Eric's designs.

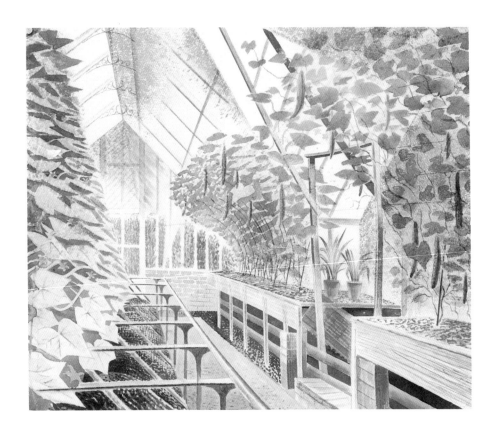

20. *The Cucumber House*, 1934
Watercolour
Tullie House, Carlisle
(CALMG: 1936.56.6)

In this watercolour one can sense Ravilious's delight in the
straight architectural planes of the structure, contrasting
with the tangle of plant life and curlicued ironwork. The taut
drawing underneath supports the delicate layers. This was one
of Ravilious's hallmarks, as Christopher Neve notes: 'At first he
can look almost natty, not so much lighthearted as lightweight,
and then you begin to see that all his drawings are compact and
strong in much the way a kite is light and strong. However airy
and amused his arrangements, they are also spare and complete.'[8]

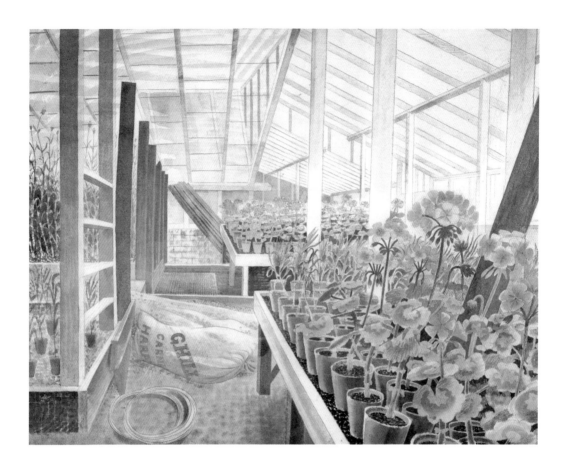

21. *Geraniums and Carnations*, 1938
Watercolour
Fry Art Gallery, Saffron Walden
(1769)
From the collection of Brian Lesmerle and
Cate Adams (née Elder). Accepted in lieu
by HM Government in 2017

Also painted at Firle (18), this interior includes more man-made elements, such as the coils of wire and the sack with lettering. Rendering the panes of glass must have been a satisfying task for the artist. Although he was never actually allied with the Surrealist movement, many of Ravilious's works have an uncanny quality of the artificially stilled: a nondescript moment made significant.

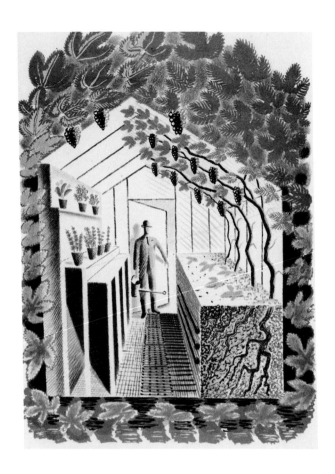

22. *The Grape House*, 1936
Lithograph
Victoria and Albert Museum, London
(V&A: C.17384)

Ravilious again explored his love of greenhouses in this print, this time featuring a bowler-hatted gardener in wellingtons and a tie. This lithograph was one of the artist's early attempts at the medium, and was originally intended for inclusion in the book *High Street*. The four shades in which it is printed – black, mid-green, blue-green and pale grey-green – give a richly verdant appearance to the encroaching vine leaves that frame the scene.

One of Ravilious's first major commissions, this mural was designed and executed for Morley College in south London. The commission was a joint one; Ravilious designed one half of the college refreshment room, and his friend Edward Bawden the other. Ravilious's fanciful rendition of a boarding house features a first-floor conservatory over a vine-covered pergola, lending the house an Edwardian feel. Sadly, as Garwood recounted in an interview after the war, the mural did not survive: 'Unfortunately this very gay and amusing painting has been destroyed by a bomb.'[9]

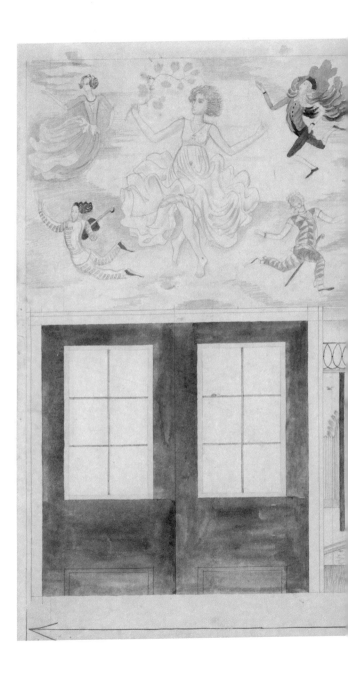

23. *Lodging House*, design for Morley College mural, 1929
Watercolour and pencil
Victoria and Albert Museum, London
(V&A: E.160–1982)

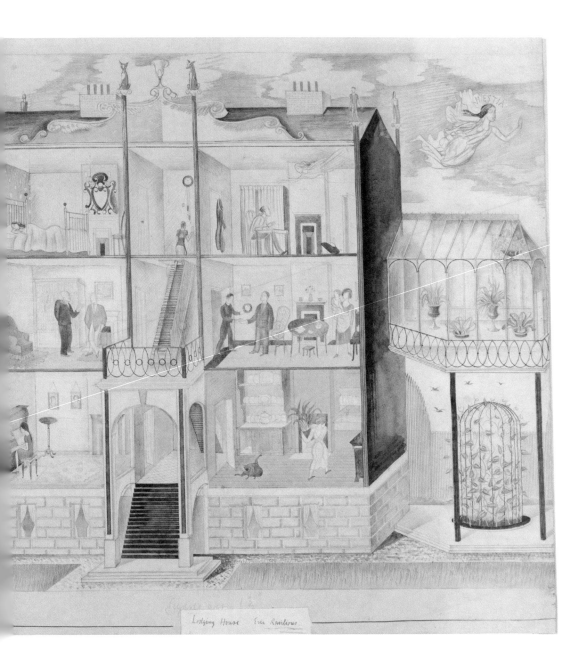

Lodging House Eric Ravilious.

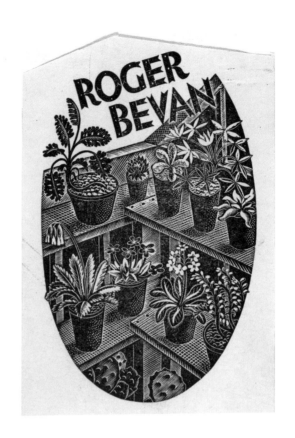

24. Bookplate for Roger Bevan, *c.*1931
Wood engraving
Victoria and Albert Museum, London
(V&A: E.551–1972)

Distinctive and appropriate for its commissioner, Roger Bevan, a founder member of the Alpine Garden Society, this bookplate gave Ravilious the opportunity to engrave pot plants. Although he was not a committed gardener himself, one can see his appreciation of the different natural forms, arranged neatly on geometric wooden shelves.

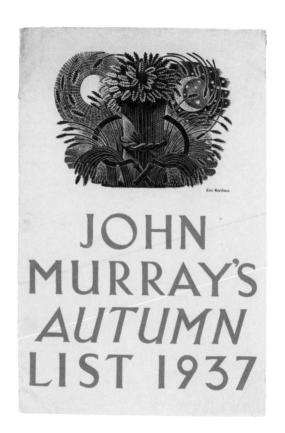

One of Ravilious's most loved engravings, this motif of harvest-time abundance was first created as a decoration for the *Cornhill Magazine* in 1933, but was reused for the firm John Murray in 1937. The carefully arranged design of sickles and sheaves of corn between a sun and moon shows Ravilious's mastery of pattern and form, and demonstrates his skill by this point at devising the appropriate arrangement and content for his commissions. This one has particularly satisfying curves that lead the eye in and out of the design.

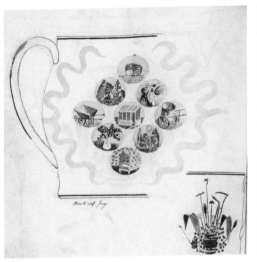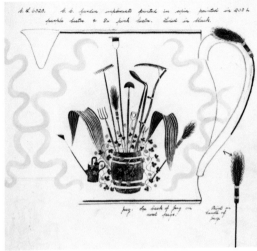

26. Garden Implements patterns
for a Liverpool jug, transfer designs
in a Wedgwood C11 pattern book, 1938
Engravings
V&A Wedgwood Collection, Barlaston
(V&A Wedgwood Collection Archive:
WoP 4676)

Transfers in the Wedgwood pattern books show one stage
of the journey from design to finished object. These printed
transfers are the Wedgwood workshop's interpretation of
Ravilious's original designs, made to be transferred on to
china. In 1938 he wrote to a friend about 'my day's work
in the garden at the back of the "Bell" [a pub in Castle
Hedingham] – collecting material for a gardener's jug.
It is unlikely I'll ever do any work in a garden but I like
other people's.'[10]

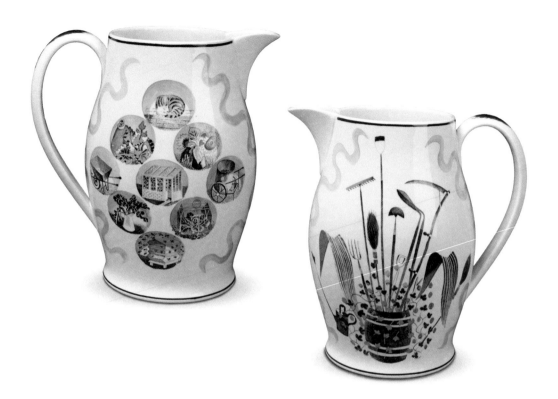

27. Lemonade jug from the Garden
Implements dinner service, made
by Josiah Wedgwood and Sons Ltd,
Etruria, 1939
Glazed earthenware with printed design
Victoria and Albert Museum, London
(V&A: CIRC.381–1939)

The finished jug evokes the joy of gardening and nature, and
prompts feelings of vitality appropriate for a jug of refreshing
lemonade. The central greenhouse motif is surrounded by a
beehive, a cat sleeping on a wall, a wheelbarrow and other
domestic paraphernalia. The typographer and designer Robert
Harling at the Kynoch Press wrote of Ravilious that 'His designs
were homely, amusing, exquisite and simple. His ornaments
ranged from curled cats to swarming beehives; his vignettes
dwelt upon boat-race formalities and gardening gaieties; his
decorations were rocking chairs and Christmas puddings.'[11]

28. *Harvest*, Edinburgh Weavers, *c.*1957
Curtain fabric
Victoria and Albert Museum, London
(V&A: T.423–1993)

29. Design for the Cotton Board, 1941
Watercolour
Private collection

In 1941, Ravilious wrote to Binyon: 'The textile business is exciting, but unfamiliar … All I seem to do is little clever piddling things – but why do women wear such tiny patterns? It confines a designer to the scale of a threepenny bit.'[12] *Harvest* (**28**), which repurposes Ravilious's Garden Implements design (**26, 27**), was produced after his death. His friends disapproved, feeling that the vignettes at different scales were not something that Ravilious would have devised. It compares unsatisfactorily with his own textile designs for the Cotton Board (**29**), unused because of the war.

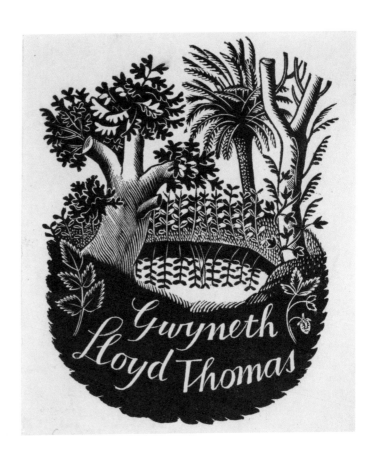

30. Bookplate for Gwyneth Lloyd
Thomas, 1931
Wood engraving
Victoria and Albert Museum, London
(V&A: E.550–1972)

Ravilious wrote to his friend, the teacher Gwyneth Lloyd
Thomas, 'I enjoyed the engraving for your book plate … but
now the picture looks so like a bird's nest – that is before a closer
examination – perhaps a last year's birds [sic] nest growing
leaves.'[13] The uneven planes for each word in Lloyd Thomas's
name lead the eye around the edge of the slightly sinister pond
with its prodigious foliage and banks of upright weeds.

66

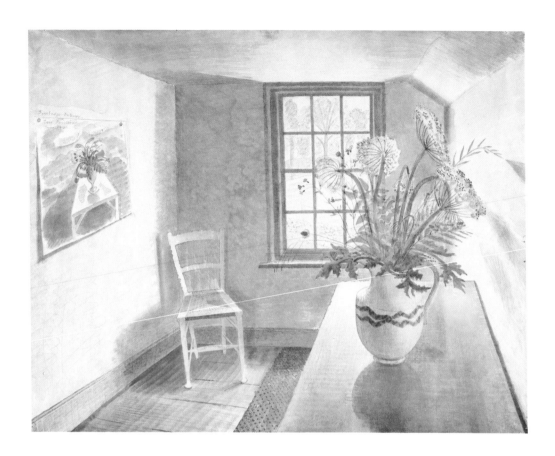

31. *Ironbridge Interior*, 1941
Watercolour
Towner Eastbourne
(EASTGL 192)
On long loan

This watercolour has the quality of quiet gaiety often associated with Ravilious. The empty chair, the large jug of flowers and the watercolour on the wall make an odd composition, but the scene is inviting. The shadows where the cow parsley touches the wall emphasize the stillness of the interior. It is surprising to think that such a light-hearted painting was made during wartime leave, at a point when the Ravilious family were struggling with childcare responsibilities and poor health.

32. Celery glass, 1934
Cut and engraved glass
Victoria and Albert Museum, London
(V&A: CIRC.312–1961)

Ravilious's foray into designing glassware came as he was being commissioned for a wide range of other commercial work. Although his designs were well received, he later dismissed this activity: 'as a change I have designed glass (a mere gesture)[,] printed pottery (for three years), furniture (again a flash in the pan)[,] book decorations and such things.'[14] This elegant celery glass with its simple foliate forms recalls Ravilious's engraved patterns for the endpapers of books (fig. 13).

33. Headpiece for 'May' in *The Twelve Moneths* perpetual calendar by Nicholas Breton (*c.*1553–*c.*1626), edited by Brian Rhys, published by the Golden Cockerel Press, 1927
Wood engraving
Victoria and Albert Museum, London
(V&A: E.565–1972)

Nicholas Breton was an English Renaissance poet and author of the *Fantasticks* (1626), a shepherd's calendar describing customs, festivals and natural history throughout the year. The text was reissued in 1927 as *The Twelve Moneths* by the Golden Cockerel Press, with illustrations by Ravilious. Each page of the calendar features a simple decorative headpiece and a more complex tailpiece depicting typical activities for the month. Ravilious created abundant strips of seasonal plants and foliage to suit the nature-themed text they were designed to enliven.

34. Headpiece for 'August' in *The Twelve Moneths* perpetual calendar by Nicholas Breton, edited by Brian Rhys, published by the Golden Cockerel Press, 1927
Wood engraving
Victoria and Albert Museum, London
(V&A: E.567–1972)

This verdant motif illustrates the summer months, which Breton describes as when 'Flora brings out her Wardrop, and richly embroydreth her greene Apron'.[15] Here, Ravilious uses a range of engraving tools to carve out a dense array of leaves and shadows as a representation of the abundance of this bountiful season.

35. Headpiece for 'September' in
The Twelve Moneths perpetual calendar
by Nicholas Breton, edited by Brian
Rhys, published by the Golden Cockerel
Press, 1927
Wood engraving
Victoria and Albert Museum, London
(V&A: E.569–1972)

Ravilious wrote to Robert Gibbings at the Golden Cockerel
Press: 'there may be a small difficulty⬚ I foresee that the
calendar side may look too rich. I shall try and make the top
rectangle as simple as I can, also, where it can be managed,
rather lighter than the one at the foot.'[16] This shows how, with
his designer's training, Ravilious thought carefully about the
layout of the whole page.

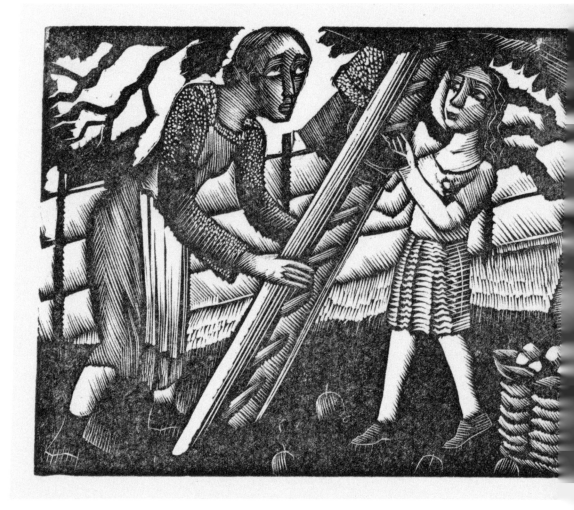

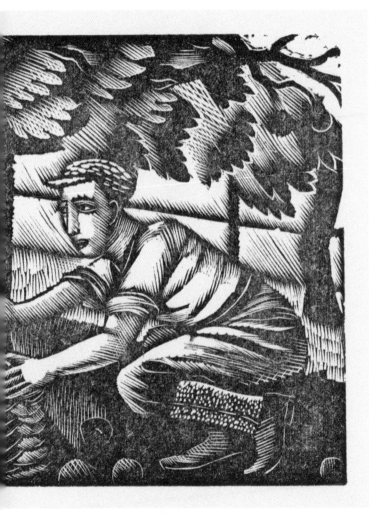

Full of activity, this calendar tailpiece celebrates the joys of autumn fruit-picking. Two women rather reluctantly steady the ladder for a figure of which we can see only the boots and trouser cuffs, a circumstance that lends the scene a slightly comic air. The figures resemble Ravilious, Garwood and Charlotte Bawden, so it is perhaps Edward Bawden who is hidden in the tree. Breton describes September as when 'the windes begin to knocke the Apples heads together on the trees, and the fallings are gathered to fill the Pyes for the Houshold.'[17]

36. Tailpiece for 'September' in
The Twelve Moneths perpetual calendar
by Nicholas Breton, edited by Brian
Rhys, published by the Golden Cockerel
Press, 1927
Wood engraving
Victoria and Albert Museum, London
(V&A: E.571–1972)

Tirzah Garwood shells peas in the garden with Charlotte Bawden, expressing the time Ravilious and Garwood lived at Brick House alongside the Bawdens and the two couples engaged in domestic tasks together. Ravilious's friends and family often appear in his works, particularly Garwood. From time to time Ravilious also appeared in her wood engravings, perhaps most memorably in *The Husband* (1929), in which he is depicted wearing a trench coat and hat while clutching two marrows.

37. *Two Women in a Garden*, 1932–3
Watercolour
Fry Art Gallery, Saffron Walden
(1736)
Purchased with assistance from the
National Heritage Memorial Fund and
the V&A/Arts Council Purchase Fund

38. Paul Androuet du Cerceau
(1623–1710), untitled print, 1670–90
Engraving
Victoria and Albert Museum, London
(V&A: 24871:1)

39. Print for *Cornhill Magazine*
autumn prospectus, 1935
Wood engraving
Victoria and Albert Museum, London
(V&A: E.580–1972)

Engravings and etchings of cornucopia date back to the fifteenth century, and Ravilious may have drawn inspiration for this motif from earlier European printmakers, such as Paul Androuet du Cerceau (38) and Cornelis Floris (1514–1575). The V&A holds an extensive collection of engraved ornament prints including works by these and similar artists, which Ravilious is likely to have explored as a student.

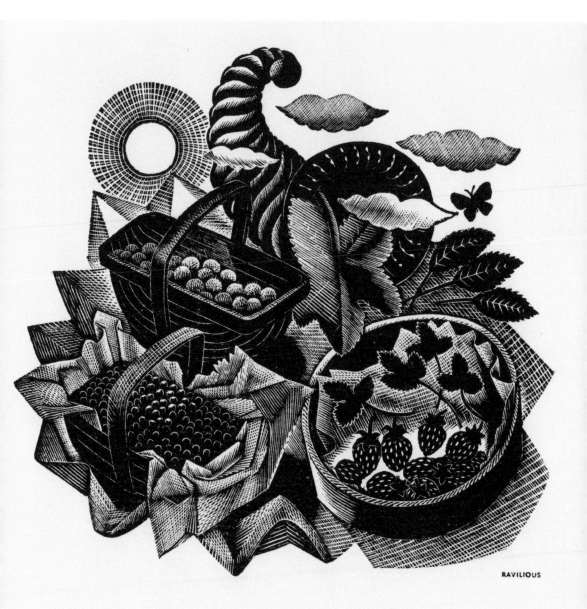

RAVILIOUS

40. Woodblocks for *The Kynoch Press Notebook*, 1932
Boxwood
Fry Art Gallery, Saffron Walden (1716)
Purchase assisted by the Art Fund

The Kynoch Press, set up for Imperial Chemical Industries in 1876, became a respected book printer under the guidance of the designer and typographer Harry Carter (1901–1982). Each of these blocks for *The Kynoch Press Notebook* is a tiny sculpture in itself. Among the array we can make out Ravilious's favoured themes of cacti, watering cans, snow scenes and swimming.

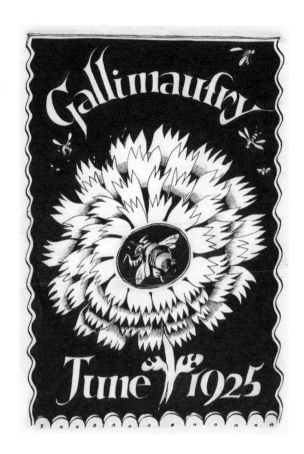

41. Cover to *Gallimaufry*, June 1925
Wood engraving
Victoria and Albert Museum, London
(V&A NAL: 38041800394330)

One of Ravilious's earliest published wood engravings, this wildly jazzy cover for the RCA student magazine shows his confidence and ambition in using the medium. His image of a bumblebee in the centre of a flower, possibly a pink (*Dianthus*), has movement and energy. His bee is well observed, with its pollen-coated legs echoing the jagged shapes of the petals.

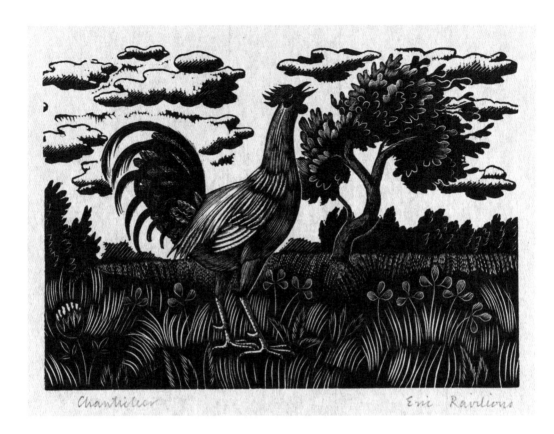

Chanticleer Eric Ravilious

42. *Chanticleer*, decoration to a
prospectus published by the Golden
Cockerel Press, 1930
Wood engraving
Victoria and Albert Museum, London
(V&A: E.589–1972)

Ravilious took on a number of commissions from Robert
Gibbings, the owner of the Golden Cockerel Press and a
wood engraver himself. Thanks to this relationship, a subject
Ravilious often revisited was cockerels. A cockerel was first
referred to as Chanticleer in the medieval fable of Chanticleer
and the Fox about the perils of pride and foolishness.

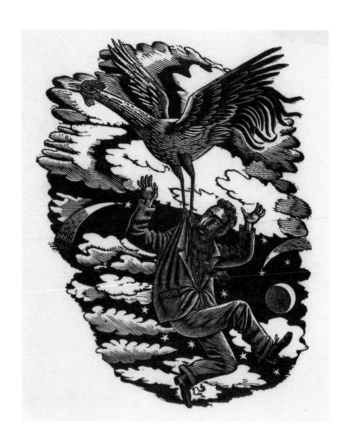

43. *Ganymede*, illustration to the Golden
Cockerel Press spring catalogue, 1931
Wood engraving
Victoria and Albert Museum, London
(V&A: E.590–1972)

Here the artist and publisher Robert Gibbings protests as he is
carried aloft by a giant cockerel, the emblem of his own private
press. This cheeky in-joke between Ravilious and Gibbings
must have amused the publisher, since the design was duly
used for the Golden Cockerel catalogue in 1931. His rumpled
suit and untied shoelace add humour, and the whole is an eye-
catching design, quite unlike anything used on other trade lists
of the era.

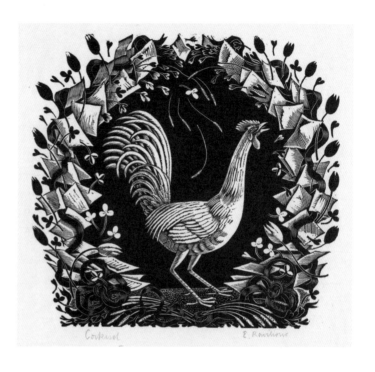

Cockerel · E. Ravilious

44. *Chanticleer I*, cover illustration
to the Golden Cockerel Press spring
catalogue, 1931
Wood engraving
Victoria and Albert Museum, London
(V&A: CIRC.365–1972)

To fulfil Robert Gibbings's brief to engrave a cockerel similar
to those found on fairground rides at the time, Ravilious has this
one crowing enthusiastically from the middle of an explosion
of book pages, flowers and ribbons. There was an interest in
folk and popular art in Ravilious's circle that he and Garwood
embraced enthusiastically. Ravilious, having grown up in an
antiques shop, had an eye for such second-hand or overlooked
treasures.

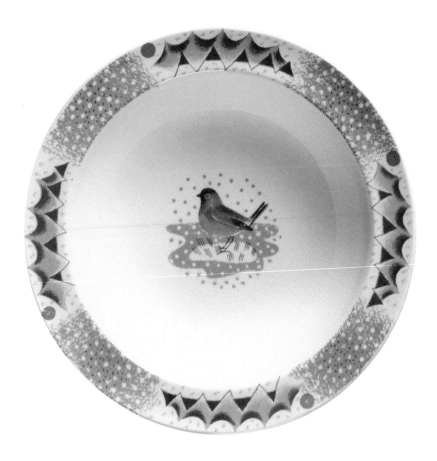

45. Bowl from the Christmas Pudding
dinner service, made by Josiah
Wedgwood and Sons Ltd,
Etruria, 1938
Glazed earthenware with printed design
Victoria and Albert Museum, London
(V&A: CIRC.309B-1961)

This festive bowl, with its grey-and-red colour scheme, is
imbued with the liveliness typical of 1930s design. The strongly
stylized zigzag holly on the rim adds drama to what might
otherwise be too staid a composition, while the polka dots
of snow and holly berries enliven this appealing pattern. The
central robin would gradually appear as one ate one's pudding.

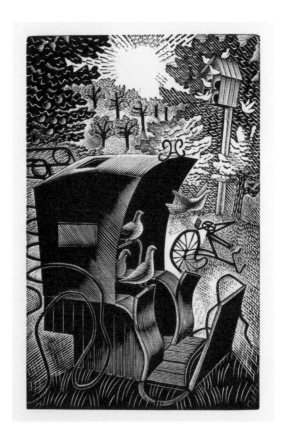

46. Illustration to L.A.G. Strong,
The Hansom Cab and the Pigeons,
published by the Golden Cockerel
Press, 1935
Wood engraving
Victoria and Albert Museum, London
(V&A NAL: L.7240–1989)

Ravilious delighted in derelict machinery and junkyards. He recalled drawing for this engraving in 'a hitherto unexplored backyard – an area wholly mud given up to every sort of junk, beds and bicycles and cartwheels with ducks and hens and black faced enormous sheep to enliven the scene – these brutes run about the place jumping pans and corrugated iron with a beautiful agility and a great deal of clatter … A hen laid an egg by my stool in the night and there was another under the cab.'[18]

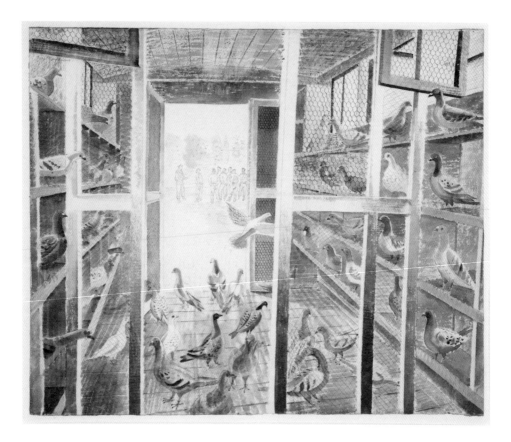

47. *Corporal Stediford's Mobile Pigeon Loft, Sawbridgeworth*, 1942
Watercolour
Whitworth Art Gallery, Manchester
(D.1947.33)

Ravilious would have been enchanted by this mobile pigeon hut, built to carry homing pigeons used in wartime to transport messages. These constructions were adopted during World War I and reused in World War II owing to their effectiveness. The meshed framework of strutted open timbers filled with birds doubtless appealed to Ravilious immensely. His restricted use of colour is well suited to painting pigeons, with only the slightest hint of colour stopping this work from being monochrome.

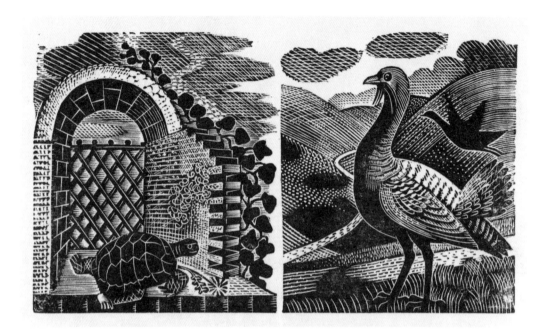

48. Proof of decoration to *The Writings of Gilbert White of Selborne*, selected and edited by H.J. Massingham, published by the Nonesuch Press, 1938
Wood engraving
Victoria and Albert Museum, London
(V&A: E.542–1972)

The commission to illustrate *The Writings of Gilbert White of Selborne* was perfectly matched to Ravilious's interests. The text, originally published in 1789, is based on letters by Reverend Gilbert White (1720–1793), a parson and naturalist, in which he described the natural history of his local area in Hampshire. White's deep affinity with nature and his locale resonated strongly with Ravilious.

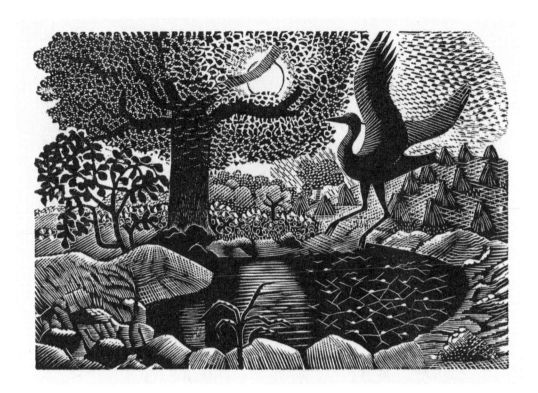

49. Proof of decoration to *The Writings of Gilbert White of Selborne*, selected and edited by H.J. Massingham, published by the Nonesuch Press, 1938
Wood engraving
Victoria and Albert Museum, London
(V&A: E.547–1972)

Ravilious found Gilbert White's classic text 'quite the best book I've ever been given to do'.[19] The engravings he produced to illustrate it include the cheerful strangeness that is present in some of his best work. A shadowed bird flaps over a black pond, representing an unsettling interlude in nature, illustrative of the summer of 1783 described by White, when climate phenomena created disturbingly red sunrises and sunsets. Set amid more tranquil illustrations of grouse and tortoises, this engraving represents a particularly English eeriness.

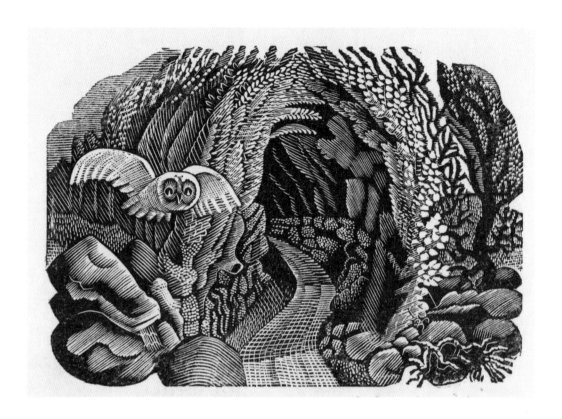

50. Proof of decoration to *The Writings
of Gilbert White of Selborne*, selected and
edited by H.J. Massingham, published
by the Nonesuch Press, 1938
Wood engraving
Victoria and Albert Museum, London
(V&A: E.537–1972)

Ravilious's engravings have inspired many since, including
the nature writer Robert Macfarlane, who observed of this
one that 'Ravilious's engraving of a Selborne holloway shows
a deep lane, over which the trees are leaning and locking, and
the entry to which is guarded by a barn owl in flight. The owl's
head is turned out towards the viewer, its eyes quizzical behind
its knight's visor of feathers.'[20] Meanwhile Ravilious's hoopoes
appear startled and about to vanish from sight.

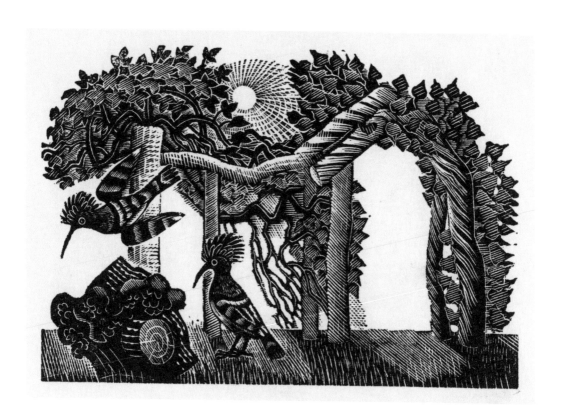

51. Proof of decoration to *The Writings
of Gilbert White of Selborne*, selected and
edited by H.J. Massingham, published
by the Nonesuch Press, 1938
Wood engraving
Victoria and Albert Museum, London
(V&A: E.539–1972)

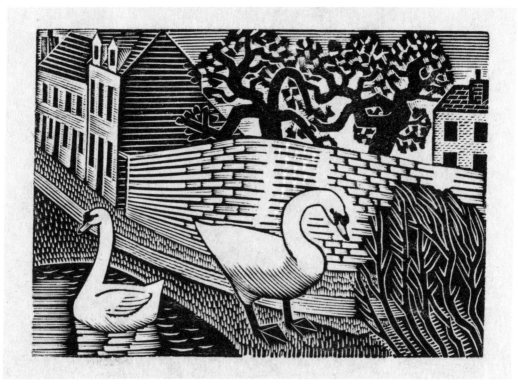

52. Illustration for an advertisement for Green Line Coaches, commissioned by the London Passenger Transport Board, 1936
Wood engraving
Victoria and Albert Museum, London
(V&A: E.574–1972)

Ravilious's illustration was designed to encourage people to travel from London by bus to enjoy the countryside. The bucolic scene of swans on a village pond shows his skill with engraving tools. If one looks closely at the marks on the pond, bricks and grass, for example, it becomes clear that they are all made with different shapes of gouge. Ravilious had a roll of around 20 engraving tools of different shapes, and became fluent in choosing the right one to create the textures and lines he had in his mind's eye. This illustration may have drawn inspiration from an engraving of swans attributed to John Bewick (53).

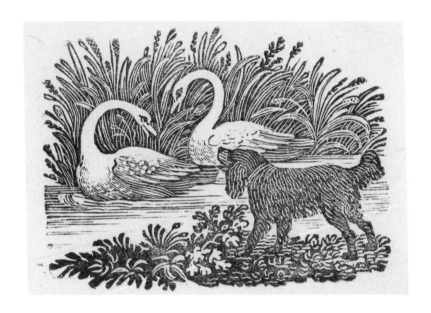

53. Attributed to John Bewick
(1760–1795), proof of illustration to
Isaac Watts, *Divine and Moral Songs
for the Use of Children*, *c.*1780s
Wood engraving
Victoria and Albert Museum, London
(V&A: E.3906–1953)
Given by Mr C.H. Petty

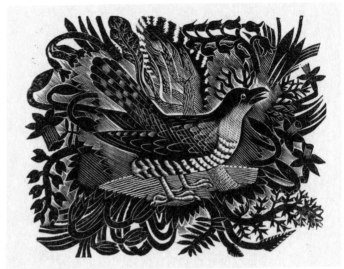

54. Illustrations to Thomas Bewick
(1753–1828) and Ralph Beilby
(1743–1817), *A General History
of Quadrupeds*, 1790
Printed volume
Victoria and Albert Museum, London
(V&A NAL: 38041800702524)

55. Proof of illustration to
the *Cornhill Magazine*, 1935
Wood engraving
Victoria and Albert Museum, London
(V&A: E.579–1972)

This engraving of a cuckoo shows Ravilious's debt to the engraver Thomas Bewick, whose books describing birds and animals were extremely popular and were considered a high point in engraving at the time of their publication (54). Although Ravilious's work is larger and simpler, and contains more abstract framing elements, he learned much from Bewick about how to create a successful vignette for book illustration. Historian Frances Spalding said of Ravilious, 'his vignettes, which imitate those of Thomas Bewick, lack the fullness and earthiness they celebrate. Far from being bucolic, they convey a brittle tension which is modern.'[21]

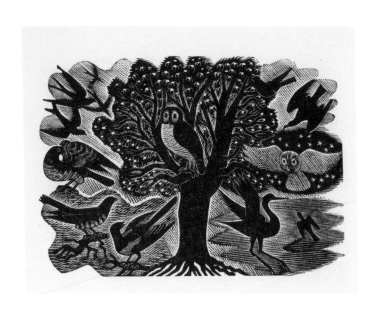

56. Illustration to *The Writings of Gilbert White of Selborne*, selected and edited by H.J. Massingham, published by the Nonesuch Press, 1938
Wood engraving
Victoria and Albert Museum, London
(V&A NAL: L.1114–1938)

Ravilious's love of birds and pleasure in depicting them is displayed in this energetic engraving. He was at times even accompanied by one while carving his blocks. From his parents' house, he wrote, 'Two engravings are done now and one of them is good I think. The canary sits on my left hand when I am working and watches as the chips fly – I have to shoo him off the block sometimes. He sits very quietly on my shoulder as long as he is allowed, but makes rather a mess of my coat … His whistle in my ear is so startling if he begins to sing.'[22]

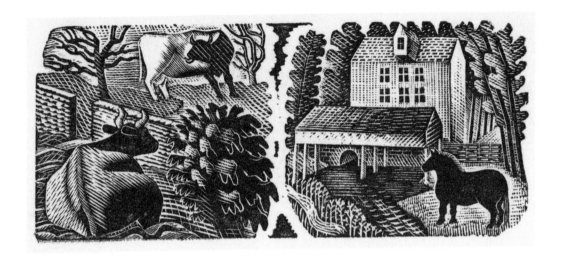

57. Proof for two of the covers for a series
of booklets issued by London Transport
to promote the Green Line Coach routes
entitled *Country Walks*, 1936
Wood engraving
Victoria and Albert Museum, London
(V&A: E.578–1972)

Farm animals often feature in Ravilious's watercolours and
engravings, and in many instances they are amusingly stocky
and appear slightly nonplussed. His choice and placement of
both machines and animals impart a gentle uncanniness and
celebrate the oddness of the everyday. The seated cow is a
reused motif from a previous painting (58), repurposed here
for a brochure encouraging trips to the countryside by coach.

58. *Two Cows*, 1936
Watercolour
Fry Art Gallery, Saffron Walden
(1301)
Purchased with assistance from the
National Heritage Memorial Fund and
the V&A/Arts Council Purchase Fund

This charming picture is a subject few young artists would
have chosen to paint. Ravilious was perhaps inspired by the
folk-art paintings of livestock he might have come across in his
father's antiques shop. He clearly enjoyed the matching poses
and sculptural hindquarters of the resting cattle, so much so
that he reused the shape in a later engraving (57).

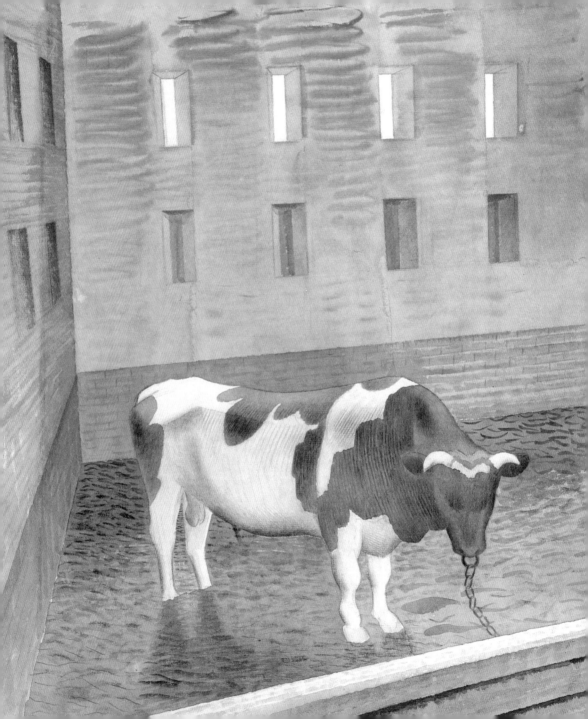

When Ravilious and Garwood first arrived at Great Bardfield, they found this bull stabled in an ancient barn called the Great Lodge. The surreal nature of the scene would have appealed to them both. Ravilious carefully conveyed the solidity and shape of the bull's body, and the play of light across its back. This painting was included in the exhibition *Artists against Fascism and War* (1935) organized by the Artists' International Association to raise funds for victims of the Spanish Civil War. Although the bull is a symbol of Spain, this Dutch breed pictured in an English barn seems somewhat peripheral to the cause.

59. *Friesian Bull, c.1935*
Pencil and watercolour
Private collection

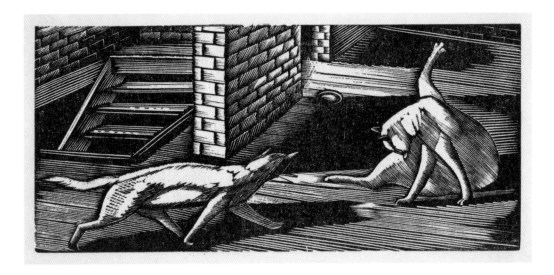

Cats are almost a Ravilious signature, cropping up regularly across his design work. Ravilious and Garwood lived happily with pets, and while at Hammersmith, west London, they adopted a stray cat that they named Pybus after the minister for transport at the time. Later they acquired a pair of pet tortoises that Garwood bought from Woolworths, one of which appears in engravings Ravilious made for *The Writings of Gilbert White of Selborne* (**48, 94**).

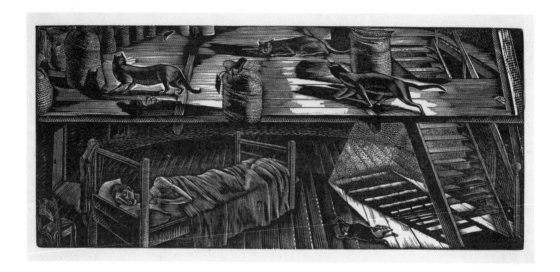

61. Proof of an illustration for the
pianola roll of music by Cecil Armstrong
Gibbs, devised as a setting for Walter
de la Mare's poem 'Five Eyes', published
by the Aeolian Company, 1926
Wood engraving
Victoria and Albert Museum, London
(V&A: E.583–1972)

The words of de la Mare's poem describe sinister black cats
hunting for rats in a flour mill while the miller sleeps. In
Ravilious's interpretation, the linearity of the stalking cats
is accentuated by the wooden planks and ladder steps inside
the mill. As he developed his engraving skill, he improved
his ability to render curves. This engraving has the sharper
angularity of his early work, but the composition is ambitious.

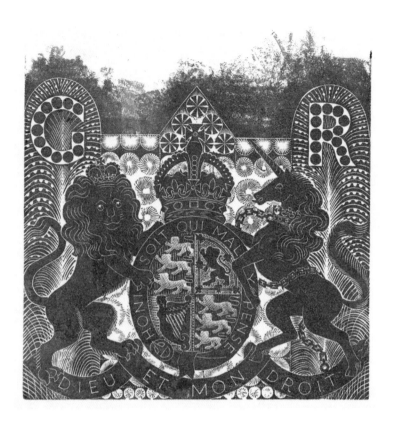

62. Proof of a cover motif for the *Guide to the Pavilion of the United Kingdom*, Paris International Exhibition, 1937
Wood engraving
Victoria and Albert Museum, London
(V&A: CIRC.396–1972)

Shown here is an unfinished proof for a section of the cover for the guide to the United Kingdom Pavilion in the International Exhibition of 1937. The final version had additional elements in light brown, and surrounding text. Ravilious's heraldic lion and unicorn draw inspiration from trade cards and theatre bills of the eighteenth and nineteenth centuries, when such motifs were included to show royal patronage. He joked that the G and R (representing Georgius Rex, or King George) stood for Ginger Rogers, his favourite actress.

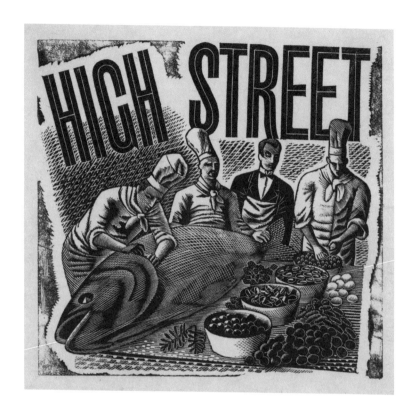

63. Illustration to J.M. Richards and
Eric Ravilious, *High Street*, published
by Curwen Press, 1938
Wood engraving
Victoria and Albert Museum, London
(V&A: CIRC.393–1972)

This frontispiece to the book *High Street* features Ravilious's
characteristic text at odd angles. The team of chefs and
waiters about to prepare a giant fish for a smart restaurant are
amusingly out of scale, while the angle of the fish echoes that
of the lettering above, seemingly propelling it out of the frame
towards the viewer.

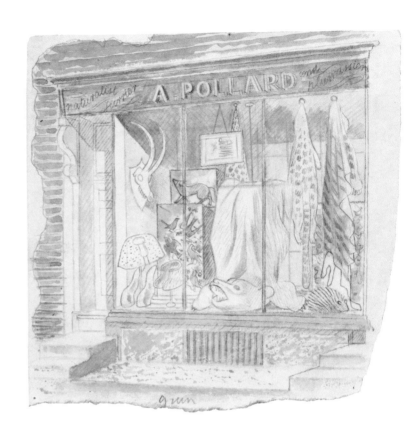

64. Design drawing for plate to
J.M. Richards and Eric Ravilious,
High Street, *c.*1937
Watercolour and pencil
Private collection

'What could be more delightful for a child than the environment
of a family shop?' asked Helen Binyon in her biography
of Ravilious.[23] Ravilious's early experiences in his father's
businesses certainly informed *High Street*, his book of lithographs
celebrating characterful shops. This sketch depicts the shopfront
of the 'Naturalist: Furrier: Plumassier' Albert Pollard. The
accompanying text recounts that 'At home Mr Pollard's foreman
has got two hundred stuffed mice, each in a different attitude' –
a detail that would have amused Ravilious.[24]

NATURALIST : FURRIER : PLUMASSIER

When a favourite dog dies, the owners sometimes want to have him stuffed, or his skin made into a rug. They go to a naturalist like Mr. Pollard to have this done. The most famous stuffed dog is the one in a glass case in Paddington Station, which used to walk about the station with a money box round his neck collecting pennies for railwaymen's widows and orphans. He was called 'Tim', and during the years before he died, in 1902, he collected over £800.

The man who stuffs animals is called a taxidermist. There are now only three firms of taxidermists working in London. Most of the work Mr. Pollard does is for hunting people, who ask him to stuff foxes or stags that they have killed. He says he does not get so many wild animals to stuff as he used to. People do not go big-game hunting so much (often they photograph the animals instead of killing them), and houses are not big enough to make room for stuffed animals and heads. But in the past he has stuffed hundreds of wild animals from all parts of the world. He once stuffed a pair of elephants for the Marquess of Bute. He had to mount them on rockers as the Marquess wanted them for his children to play on in the nursery. Sometimes he stuffs animals for museums. The other day he was asked to mount up the bare skeleton of a prize bull-dog that had died. The owner preferred it like that.

Often with big animals it is only the head that is preserved, especially if it has remarkable horns, like the one in the left side of Mr. Pollard's window. The head—or sometimes just the skull—and the horns are mounted on a wooden shield to hang on the wall.

An animal with a beautiful skin, like a tiger or a bear,

28

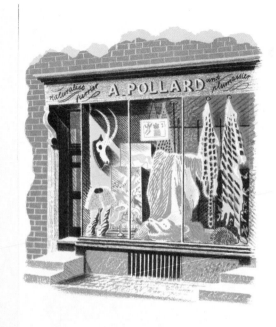

65. Illustration to J.M. Richards and Eric Ravilious, *High Street*, published by Curwen Press, 1938
Lithograph
Victoria and Albert Museum, London
(V&A NAL: 4025068)

James Russell has researched the fate of the shops Ravilious depicted in *High Street*, and he notes of Albert Pollard's business near Baker Street that 'although this was undoubtedly one of those archaic, picturesque concerns that Ravilious seemed to love, it wasn't changing tastes that put Mr Pollard out of business during the last years of the war, but a German rocket.'[25] By including this business, Ravilious draws attention to the ways in which nature is processed and used as decoration by human beings.

66. *The Causeway, Wiltshire Downs*, 1937
Watercolour
Victoria and Albert Museum, London
(V&A: P.5–1938)
Given by Contemporary Art Society

The changeable British weather permeates Ravilious's work, and it is perhaps this, rather than his focus on landscape, that explains his categorization as a peculiarly English artist. His ability to capture moments that are not-quite-sunny or bright-but-a-bit-too-bracing is exact. His love of Francis Towne's work (fig. 16) indicates the kind of landscape he desired: full of browns, purples and blues. Ravilious's painting technique often relied on patterns applied with a starved (semi-dry) paintbrush. This subtle use of repeated dots, dashes, stripes and checks allowed Ravilious to convey grassy hills, high hedges or sunlit seas with soft precision.

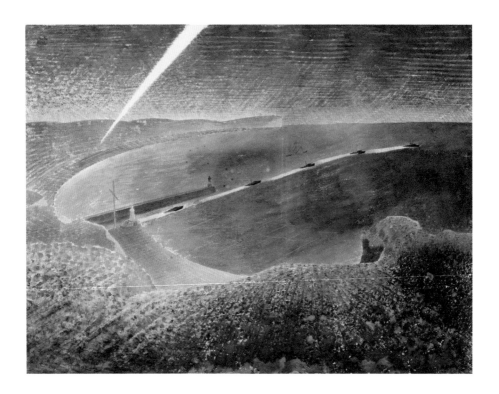

67. *Coastal Defences*, 1940
Watercolour
Imperial War Museum
(Art.IWM ART LD 5662)

Ravilious pushed his technique to full effect in his war work,
creating pictures of the wakes of ships, or the view through
the propeller of a plane in action, in which the whole page is
a rippling expanse of meshed patterns. In this watercolour
with its restricted palette the sea and night sky look like a
bruise. The piercing beam from a searchlight illuminating
military boats going to sea provides the only contrast to the
sombre shades.

If one looks closely, Ravilious's colour notes are still visible in this watercolour: the word 'grey' in the right-hand sky, and 'yellow' at the top of the patch of corn (fig. 12). These aides-memoires appear in many of his watercolours and bear testimony to his working method. Ravilious rated this work highly, writing to Helen Binyon, 'I must show you the one good picture painted this summer of the Wilmington Giant. You would like the sky. It is what you call a clever sky.'[26]

68. *The Long Man of Wilmington*, 1939
Watercolour
Victoria and Albert Museum, London
(V&A: P.3–1940)

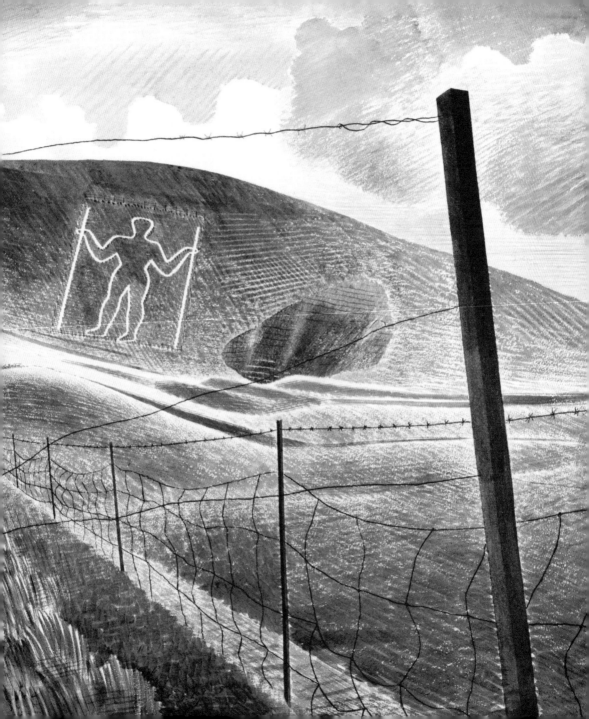

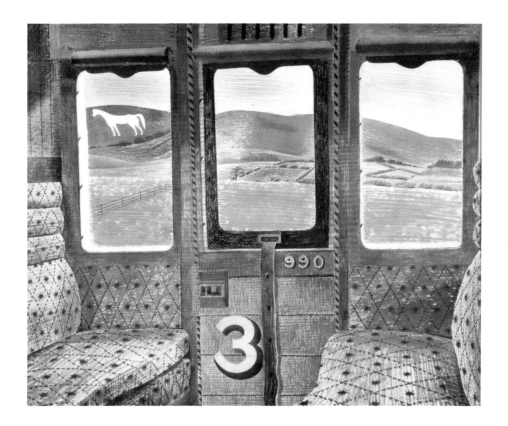

69. *Train Landscape*, 1939
Watercolour
Aberdeen Art Gallery
Purchased in 1940 with income
from the Macdonald Bequest

In many instances Ravilious produced work with the advice of his wife, Tirzah Garwood. Her account of her involvement in this picture, one of his more famous works, reveals how she collaged his painting to make a better image: 'He often doctored paintings that went wrong and when he painted two attempts of the railway carriages on the Eastbourne and Hastings train, neither so [sic] of which he wholly approved, I cut them up and joined together the best bits and made a satisfactory whole.'[27]

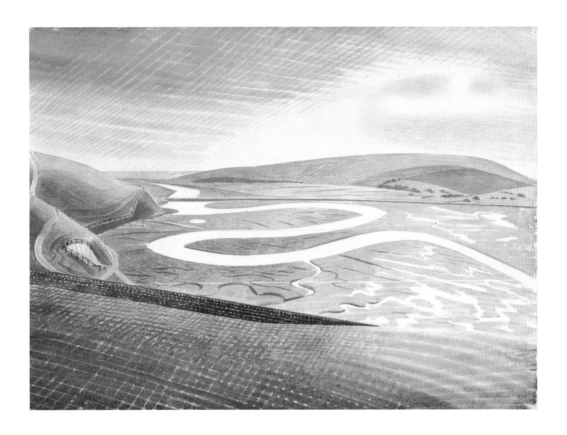

70. *Cuckmere Haven*, 1939
Watercolour
Towner Eastbourne
(EASTGL 176)
On long loan

This work shows the influence of John Robert Cozens, whose work Ravilious fell in love with as a student. One of Cozens's paintings that Ravilious would have seen at the V&A in the early 1920s depicts a valley in the Swiss Alps (fig. 5). We can see in Ravilious's later painting that he has adapted this epic landscape style to celebrate the Sussex coastal landscape of his childhood. Ravilious's signature cross-hatched brushwork effect can be seen sculpting the curve of the nearest hill and indicating impending rain in the lowering sky.

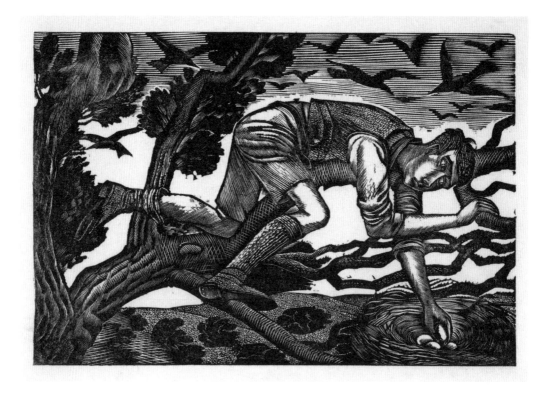

71. *Boy Birdsnesting*, 1927
Wood engraving
Victoria and Albert Museum, London
(V&A: E.582–1972)

Douglas Percy Bliss described Ravilious's method for this engraving: 'He fashioned "scorpers" (a sort of miniature gouge) from odd pieces of metal, and soon was obtaining on box-wood these qualities of dot and speck and dash and dab in white-line with which he enriches his blocks. He will spend hours covering a passage with tiny dots or flecks to get an even grey effect, such as the ground beneath the figure of his *Boy Birdsnesting*.'[28] One can see similar attention to texture in the boy's knitted socks and vest.

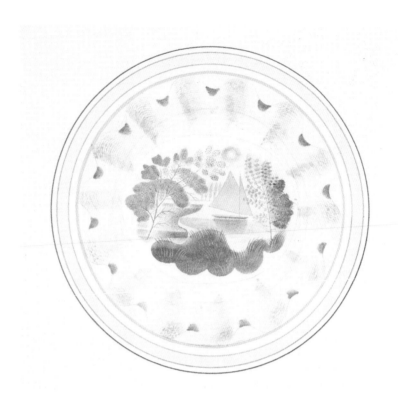

72. Design for a plate in the Travel
dinner service, made for Josiah
Wedgwood and Sons Ltd,
Etruria, 1938
Watercolour
V&A Wedgwood Collection, Barlaston
(V&A Wedgwood Collection Archive:
WoP 4672)

The gently scalloped edges of this design's central vignette
suggest a cloud with the sun radiating from behind it. Aimed
at children, the motif encourages the user to finish their food
in order to see the picture beneath. The curvaceous pattern
around the rim gives the effect of a fluted edge to this in fact
quite sturdy dinnerware. It was produced in a colourway of black
and pale blue on grey, and featured planes, boats and trains,
suggesting that Ravilious had a boyish audience in mind.

73. 'April', illustration to the
Lanston Monotype Almanack, 1929
Wood engraving
Victoria and Albert Museum, London
(V&A: E.558–1972)

74. Woodblock for 'April', for the
Lanston Monotype Almanack, 1929
Boxwood
Victoria and Albert Museum, London
(V&A: E.1238–1974)

Ravilious's surviving woodblocks demonstrate the challenges
of engraving. The delicacy of his line and the fluency of his
carving impart a propulsive energy to the final prints. They
retain the feeling of something handheld and shaped by hand.
The blocks show where he changed tools, perhaps even where
he took a tea break to come back to an area of mark-making.
'April' shows Aries the ram floating above a mysterious and
androgynous striding form, possibly the same figure inspired
by the Long Man of Wilmington shown in 'May' (75).

75. 'May', illustration to the
Lanston Monotype Almanack, 1929
Wood engraving
Victoria and Albert Museum, London
(V&A: L.4637–1934)

76. Woodblock for 'May', for the
Lanston Monotype Almanack, 1929
Boxwood
Victoria and Albert Museum, London
(V&A: E.1239–1974)

Ravilious engraved the signs of the zodiac for his calendar commission from the Lanston Monotype Corporation. He interpreted them idiosyncratically, setting them all in the landscape of the South Downs, as well as incorporating other myths. In the preface to the almanack, he discusses his thoughts about the zodiac and the reasons for his alterations. He proposes, for example, that the Long Man of Wilmington, a chalk figure from which he long took inspiration (68), might in fact have been female and a representation of Virgo. In his rendition we therefore see an androgynous figure standing above a starlit dewpond.

A note by Ravilious on the
preparatory drawing for this
engraving reads, 'Peggy
or Girl seated on a grassy
bank or Persephone – finally
Proserpina', suggesting
that his good friend Peggy
Angus was the model for
the figure. It also reveals
how Ravilious saw myth
embodied in his everyday
life, enabling his friends to
morph into goddesses. This
engraving was commissioned
by Douglas Percy Bliss, who
was particularly pleased with
the skilful 'scorper work' in
the figure's skirt.[29]

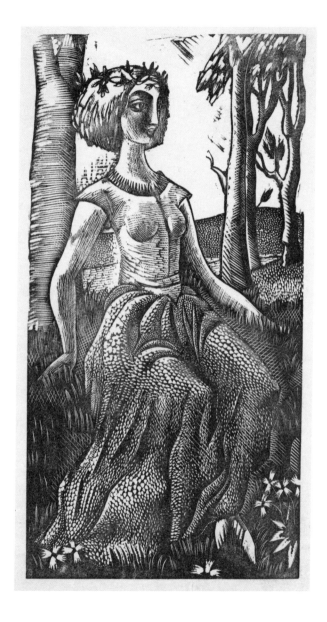

77. *Proserpina*, proof illustration
to *The Woodcut: An Annual*, no. 2,
edited by Herbert Furst, published by
The Fleuron, printed by the Curwen
Press, 1928
Wood engraving
Private collection

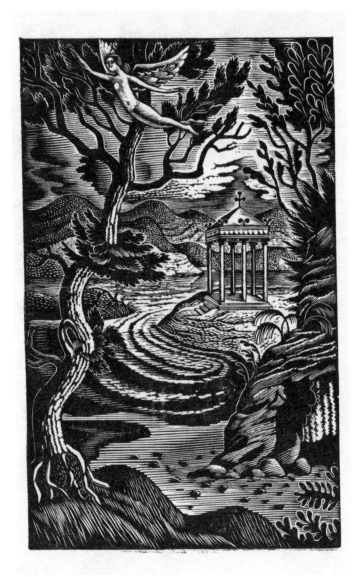

This engraving, designed for a book of poems by Harold Monro, shows Ravilious's preoccupation with mythical and celestial beings such as embodiments of the zodiac and angels. This interest might seem at odds with his fidelity to landscape, but it is an expression of his acute sensitivity to place and atmosphere. Like Stanley Spencer's visions, Ravilious's flights of fantasy suggest that the otherworldly can break through and manifest itself in the everyday.

78. *Elm Angel*, 1930
Wood engraving
Victoria and Albert Museum, London
(V&A: E.576–1972)

Made to illustrate the story of Malchus, a wealthy Alexandrian who becomes a hermit, this engraving was for Ravilious's first published commission. The angularity of the image reflects his relative lack of experience at the time. As his skill with engraving tools developed, he found a wider range of mark-making that made curves and shadows easier to delineate. His disappointment with the way his early works looked in print taught him valuable lessons about how to engrave for publications.

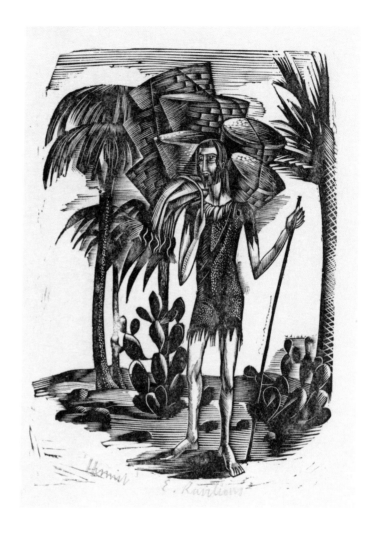

79. Illustration to Martin Armstrong,
Desert: A Legend, published by Jonathan
Cape, 1926
Wood engraving
Victoria and Albert Museum, London
(V&A: 585–1972)

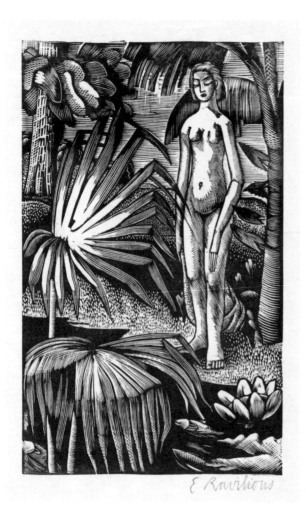

E Ravilious

Writing about Ravilious's work, his fellow RCA student Douglas Percy Bliss described how 'Pallid, large-eyed girls and slim loose-limbed boys drift sleepily through his drawings, caress each other tenderly, or look blankly out into vacancy as the folk do in medieval tapestries.'[30] This early engraving shows Ravilious relishing the foreground foliage, but having rather less success with the figure's hands and feet.

80. Dust-jacket illustration to Ronald Fraser, *Flower Phantoms*, published by Jonathan Cape, 1926
Wood engraving
Victoria and Albert Museum, London
(V&A: E.584–1972)

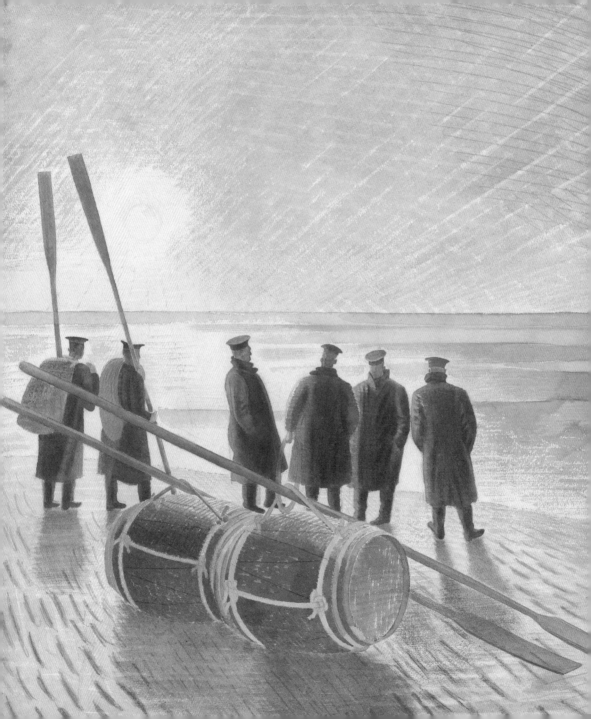

These men are shown defusing a German magnetic mine at Whitstable oyster beds, on the north coast of Kent; they were later awarded a Distinguished Service Cross for the task. Ravilious was pleased to hear of their medals, noting, 'Simply having one's thigh boots full of ice cold sea water for an hour seems worth it to me.'[31] Although faceless, the figures in this painting tell an eloquent story through their poses and attitudes. Three men work intently while the waiting figures in the foreground chat, caught between boredom and anxiety.

81. *Dangerous Work at Low Tide*, 1940
Watercolour
Imperial War Museum
(Art.IWM ART 17863)

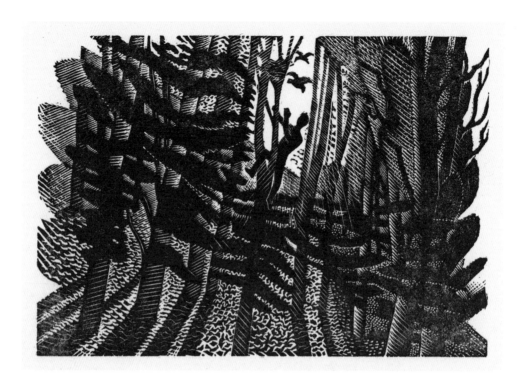

82. Proof of decoration to *The Writings of Gilbert White of Selborne*, selected and edited by H.J. Massingham, published by the Nonesuch Press, 1938
Wood engraving
Victoria and Albert Museum, London
(V&A: CIRC.386–1972)

In this scene for *The Writings of Gilbert White of Selborne* Ravilious returns to the theme of birds-nesting (71), though this time with a more sinister air. The shadowed trees loom around the central figure, while distressed birds fly above him to protect their nest. Ravilious uses complex patterns to give the effect of the setting sun shining through the trees. Areas left uncarved to indicate blocks of branches ripple across the engraving. The overall impression is disconcerting and uncanny, a mood that many of Ravilious's illustrations for White's book share.

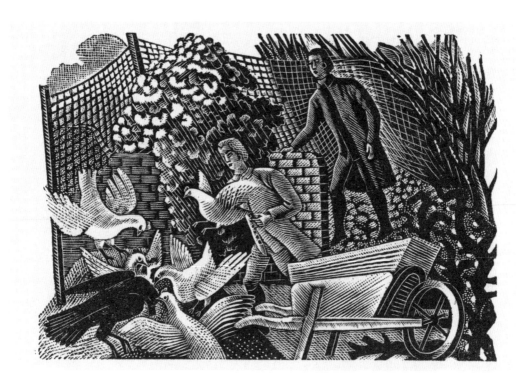

83. Proof of decoration to *The Writings of Gilbert White of Selborne*, selected and edited by H.J. Massingham, published by the Nonesuch Press, 1938
Wood engraving
Victoria and Albert Museum, London
(V&A: E.545–1972)

This engraving illustrates Gilbert White's account of a neighbour who netted and caught a sparrowhawk that had been taking his chickens. The neighbour maimed the hawk and threw it among the remaining chickens to be killed. This dark story is made less bloodthirsty in Ravilious's illustration, which shows a milder version of the encounter. A wheelbarrow, one of his often repeated motifs, dominates the foreground.

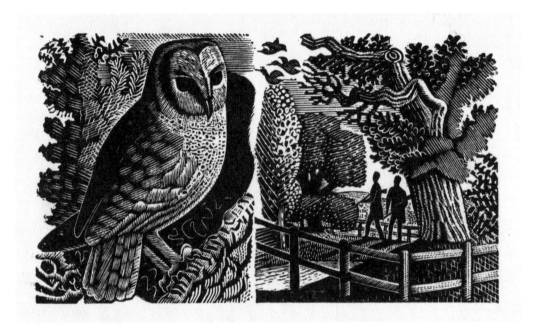

84. Proof of decoration to *The Writings of Gilbert White of Selborne*, selected and edited by H.J. Massingham, published by the Nonesuch Press, 1938
Wood engraving
Victoria and Albert Museum, London
(V&A: E.543–1972)

The foliage in this pair of illustrations shows Ravilious's confidence at engraving elements from nature. His lively and varied mark-making cleverly expresses leafy trees and abundant hedgerows. Curves, crosses, dashes and dots from his engraving tools multiply to give shape and texture to different types of leaf and branch, and repeated patches of parallel lines convey the pattern of the owl's feathers. The silhouetted figures out hunting appear diminutive compared to the rich natural world that surrounds them.

85. Illustration to Martin Armstrong, *Fifty-Four Conceits: A Collection of Epigrams and Epitaphs Serious and Comic*, 1933
Wood engraving
Victoria and Albert Museum, London
(V&A: E.553–1972)

Ravilious introduces an unusual dot-and-dash curved line in this engraving to convey the current of the sea and give the impression of being underwater. Eddying back on itself along the curved edge of the block, this sinuous feature gives movement and rhythm to the composition. Although the image was made to illustrate a poem about suicide, the mood is calm and inviting, perhaps suggesting the allure of death.

'Church under a hill' E. Ravilious.

86. *Church under a hill*, 1927
Wood engraving
Victoria and Albert Museum, London
(V&A: E.1892–1927)

This early engraving shows the parish church of St Michael the Archangel at Litlington in East Sussex. Although Ravilious's childhood experiences with his father had put him off organized religion, he still took pleasure in country churches and valued their visual role in the English landscape. The range and form of marks already show him finding his confidence with engraving.

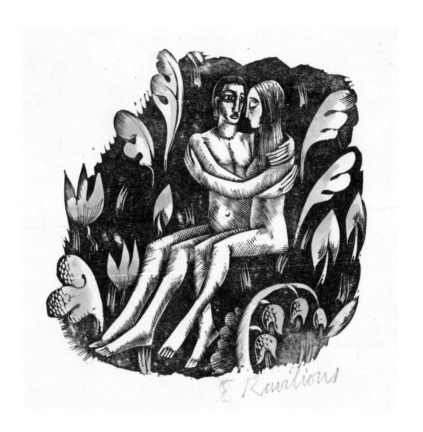

87. *Malchus and Helena*, illustration to Martin Armstrong, *Desert: A Legend*, published by Jonathan Cape, 1926
Wood engraving
Private collection

Ravilious's close friend Edward Bawden recalled Eric's engraving technique: 'He never made the slightest mistake or showed the faintest indecision. His cutting was superb. Usually he covered the block with a wash of white paint, then drew in pencil on it, often with a good deal of dark shading. Then with the graver he cut slowly and decisively. Eric must have had a remarkably clear mental image of what he intended to do.'[32] This early work shows Eric experimenting with simple colour additions, a style absent from later engravings.

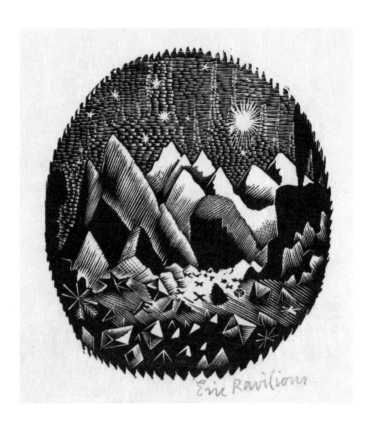

88. Illustration to Martin Armstrong,
Fifty-Four Conceits: *A Collection of
Epigrams and Epitaphs Serious and
Comic*, 1933
Wood engraving
Victoria and Albert Museum, London
(V&A: E.552–1972)

This lunar landscape is more angular and fantastical than
Ravilious's other work. Although simple, the design has striking
graphic qualities. Ravilious's design education made him adept at
creating lively vignettes and motifs, whether they were intended
for a page, a plate, a handkerchief or a vase. The spiky rocks lend
themselves to the kind of shape that engraving tools can make,
but the textured depth of space behind is conveyed by repetitive
tool-marks that show Ravilious's rhythmic work on the block.

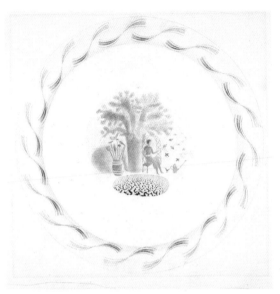
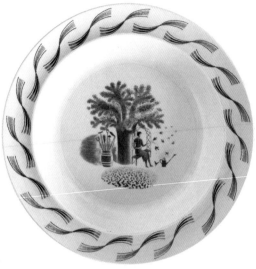

89. Design for Garden dinner service
for Josiah Wedgwood and Sons Ltd,
Etruria, 1937
Watercolour
Towner Eastbourne
(EASTGL 157)
On long loan

90. Garden bowl, made by Josiah
Wedgwood and Sons Ltd, Etruria, 1938
Glazed earthenware with printed design
Victoria and Albert Museum, London
(V&A: CIRC.474–1948)

This design captures the enjoyment of restful moments in the
garden. A woman sits feeding birds, one of which stands pertly
at her feet, echoing the shape of a nearby watering can. The
textured ellipse in the foreground is almost certainly a collaged
snippet from one of Garwood's marbled papers. The finished
plate, with its tranquil scene edged by repeated twists in black
and yellow, is a pleasing piece of dinnerware. This pattern
appears to have been considered a success by Wedgwood,
since the firm commissioned Ravilious to design a second
set, Garden Implements, in a similar style (**26, 27**).

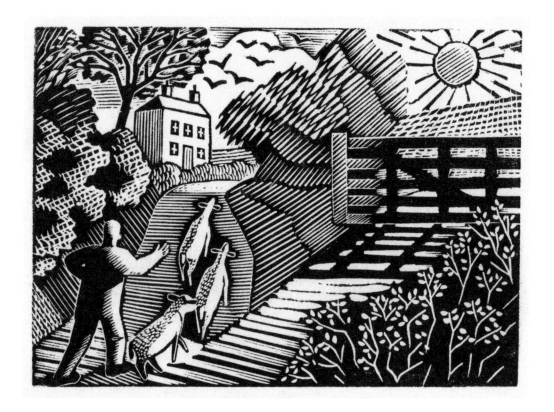

91. Proof of an advertisement issued
by London Transport to promote the
Green Line Coach routes, 1936
Wood engraving
Victoria and Albert Museum, London
(V&A: E.575–1972)

Harking back to the work of Samuel Palmer (fig. 6), Ravilious
executed this bucolic scene with a childlike simplicity. His ever
present interest in travel, weather and landscape was used to
full effect to encourage people to visit the countryside using
public transport. Every area of the block has a different rhythm
and texture as Ravilious plays with the effects of black-on-
white and white-on-black.

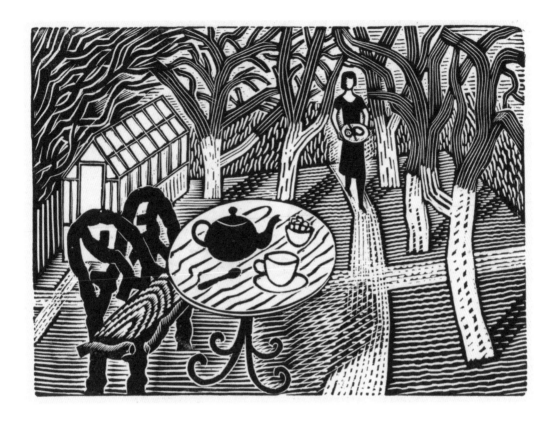

92. *Afternoon Tea*, designed for London
Transport Green Line Coach route
announcement, 1936
Wood engraving
Royal Academy, London
(08/1370)

This simple wood engraving for an advertisement contains
several classic Ravilious motifs: a greenhouse, an outdoor
picnic and a splendid 'Brown Betty' teapot. Ravilious was
deeply fond of tea and, as his wife might well have attested,
'women bringing the artist tea' could arguably be considered
one of his signature themes. The original design included
a garden watering can in the foreground, another domestic
object that Ravilious loved to depict.

Ravilious enjoyed swimming with friends, in both the River Thames at Hammersmith and the River Pant at Great Bardfield. It is therefore unsurprising that such pursuits came to mind when he created this composition to convey the month of 'June'. The image depicts a cross section through the water, revealing the swimmer moving along on a slightly different plane from that of the bank and tree.

93, Tailpiece for 'June' in *The Twelve Moneths* perpetual calendar by Nicholas Breton, edited by Brian Rhys, published by the Golden Cockerel Press, 1927
Wood engraving
Victoria and Albert Museum, London
(V&A: E.566–1972)

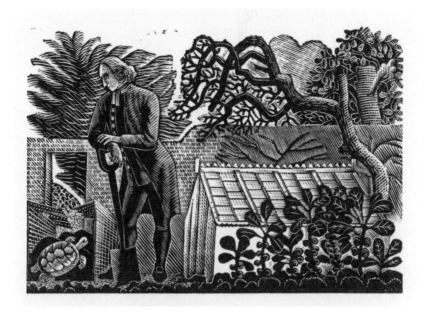

94. V&A: E.546–1972

95. V&A: E.549–1972

96. V&A: E.538–1972

Proofs of decoration to *The Writings of Gilbert White of Selborne*, selected and edited by H.J. Massingham, published by the Nonesuch Press, 1938
Wood engravings
Victoria and Albert Museum, London

These engravings for *The Writings of Gilbert White of Selborne* show Ravilious exploring different relationships between people and nature. The three vignettes show the naturalist leaning on his spade while contemplating his tortoise; a wild-eyed hermit outside his grotto; and a horse and rider startled by fire. Here Ravilious moves beyond his more common theme of domestic gardens and landscapes to indicate more spiritual relationships with the natural world, and even frightening natural phenomena.

Tea in the garden of his friend and fellow artist Peggy Angus at her house on the Sussex Downs was a frequent event in Ravilious's life. He loved Furlongs for its remote location and Angus's charm and her eccentric and basic mode of living. He found his frequent stays there inspiring, and made much of his finest work in the surrounding area. Angus had a galvanizing effect on many artists; a teacher and artist herself, she was passionate that everyone could and should make art.

97. *Tea at Furlongs*, 1939
Watercolour
Fry Art Gallery, Saffron Walden
(856)

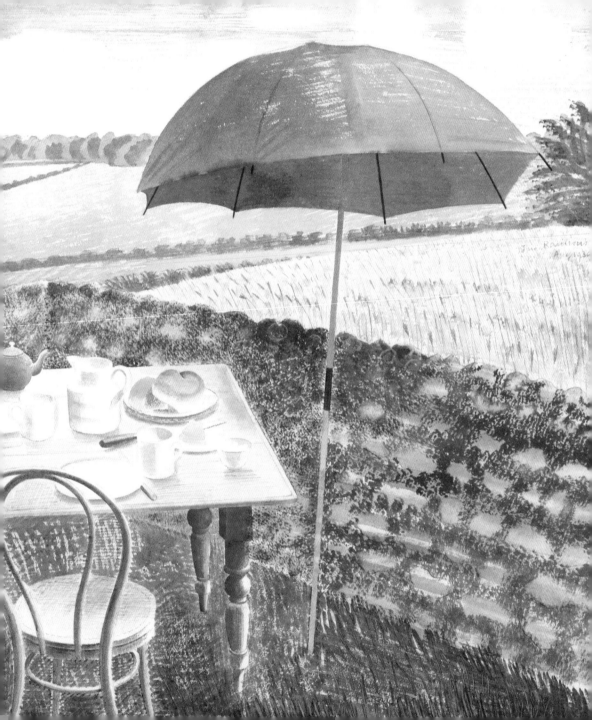

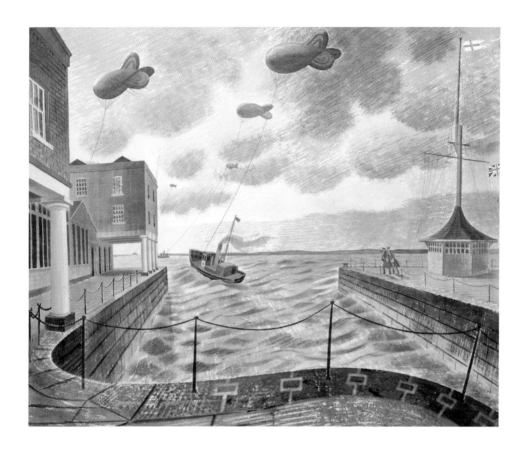

98. *Barrage Balloons outside*
a British Port, 1940
Watercolour
Leeds Art Gallery
(LEEAG.PA.1947.0028.0037)

The curves in this image set up a strong visual rhythm – the swoop of the harbour wall, the lap of the waves inside it, the bulbous barrage balloons echoing the plump grey clouds, and the prow of the jaunty tugboat setting off. Painted by Ravilious in his capacity as an official war artist, it has a curiously optimistic tone despite the evident signs of conflict. It was perhaps approved by the War Office precisely because of its potential to improve morale.

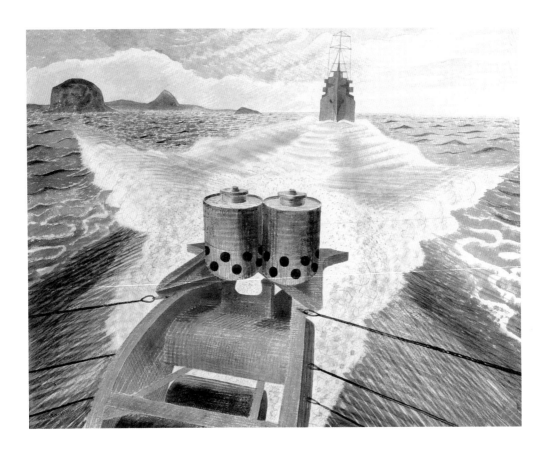

99. *Passing the Bell Rock*, 1940
Watercolour
Museums Sheffield
(VIS.1891)

War afforded Ravilious the opportunity to paint from ships at sea. This image showing the wake of a boat as it passes one of Britain's great rock lighthouses was painted near the Firth of Forth in south-eastern Scotland. In the same year, aboard the HMS *Highlander* in Norway, Ravilious wrote, 'The wake from a ship like this is very remarkable and I'm trying to do something with it, by day or night.'[33]

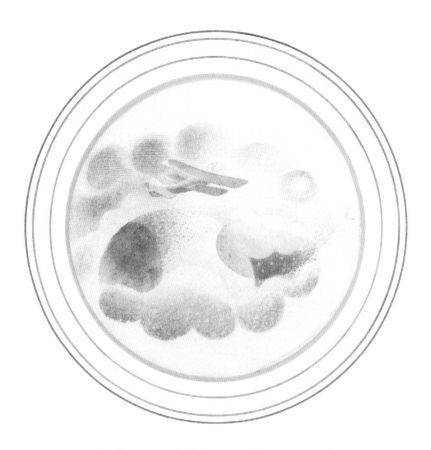

100. Design for Travel dinner service, made for Josiah Wedgwood and Sons Ltd, Etruria, 1938
Watercolour
V&A Wedgwood Collection, Barlaston (V&A Wedgwood Collection Archive: WoP 4674)

Ravilious reused his favourite themes across different media. This motif of a biplane in flight was based on an earlier engraving (101) and recalls his childhood fascination with the planes of the Eastbourne Flying School. The plane contains the only straight lines in the design, while the clouds, landscape and sun are formed by spheres and curves. The clouds above the plane have the look of thumbprints, reminding the viewer of the hand of the maker.

101. *The Young Airman*, illustration to
Martin Armstrong, *Fifty-Four Conceits:
A Collection of Epigrams and Epitaphs
Serious and Comic*, 1933
Wood engraving
Victoria and Albert Museum, London
(V&A: E.555–1972)

Originally created in 1933, this engraving was reused in 1936
to illustrate 'A Cross to Airmen' in *Poems* by Thomas Hennell.
The gaiety that permeates Ravilious's work was manifest even
in his wartime paintings. Christopher Neve describes the
pleasures of Ravilious's watercolours as 'those of feeling well,
of being young, and of seeing, for once, absolutely clear-eyed'.[34]
The image of a lone aircraft casting a vivid shadow on the
ground below presages Ravilious's own death while on an
airborne search expedition.

Notes

INTRODUCTION

1 Ullmann, Whittick and Lawrence 2008, vol. 1, p. 187
2 Letter from Eric Ravilious to Helen Binyon, November 1936. Ullmann, Whittick and Lawrence 2008, vol. 2, p. 337
3 Binyon 1983, p. 21
4 Skipwith and Webb 2018, pp. 28–9
5 Quoted in Binyon 1983, pp. 27–8
6 Unpublished document quoted in Ullmann, Whittick and Lawrence 2008, vol. 1, p. 87
7 Ullmann 2016, pp. 93–4
8 Edward Bawden, written recollection in the exhibition catalogue Eric Ravilious 1903–1942 (The Minories, Colchester, Essex, January 1972), p. 7
9 Ullmann, Whittick and Lawrence 2008, vol. 1, p. 81
10 Quoted in Binyon 1983, p. 4
11 Saunders and Yorke 2015, p. 8
12 Binyon 1983, p. 62
13 Friend 2018, p. 14
14 Ullmann 2016, p. 279
15 Richards 1972, p. 9
16 Ullmann 2016, pp. 167–8
17 Ibid., p. 479
18 Powers 2003, p. 36
19 Ibid., p. 36
20 In Memoriam, BBC Third Programme, broadcast 20 January 1947
21 Binyon 1983, p. 22
22 Sharon Gater at the Wedgwood Museum, quoted in Andrew Casey, 20th Century Ceramic Designers in Britain (Woodbridge, 2001), p. 219
23 Richards 1972, p. 17
24 Gill Saunders, Afterword, in J.M. Richards and Eric Ravilious, High Street (London, 2022), n.p.
25 Letter from Eric Ravilious to Helen Binyon, 10 September 1939. Ullmann 2002, p. 24
26 Richards 1972, p. 18
27 Christopher Neve, 'Eric Ravilious's England', Country Life, xiii/20 (April 1972), p. 916
28 Ullmann 2002, p. 93
29 Letter from Eric Ravilious to E.M.O'R. Dickey, July 1940. Ullmann 2002, p. 105
30 Letter from Eric Ravilious to Tirzah Garwood, July 1942. Ibid., p. 247
31 Neve 1990, p. 35
32 Ullmann 2016, pp. 433–4

PLATES

1 Letter from Eric Ravilious to Helen Binyon, February 1938. Ullmann, Whittick and Lawrence 2008, vol. 2, p. 386
2 Letter from Eric Ravilious to E.M.O'R. Dickey, December 1941. Ullmann 2002, p. 198
3 John Piper, 'Lithographs by Eric Ravilious of Shop Fronts', Signature, 5 (March 1937), p. 48
4 Ullmann, Whittick and Lawrence 2008, vol. 2, p. 286
5 Quoted in Eric Ravilious 1903–1942, exh. cat. (Colchester, 1972), p. 7
6 Ullmann, Whittick and Lawrence 2008, vol. 2, p. 385
7 Christopher Neve, 'Eric Ravilious's England', Country Life, xiii/20 (April 1972), p. 917
8 Neve 1990, p. 28
9 In Memoriam, BBC Third Programme, broadcast 20 January 1947
10 Letter from Eric Ravilious to Diana Tuely, June 1938. Ullmann, Whittick and Lawrence 2008, vol. 2, p. 414
11 Harling 1946, p. 13
12 Letter from Eric Ravilious to Helen Binyon, April 1941. Ullmann 2002, p. 150
13 Ullmann, Whittick and Lawrence 2008, vol. 1, p. 100

14 Letter from Eric Ravilious to
Richard Seddon. Ullmann 2002,
pp. 206–7

15 Nicholas Breton, *Fantasticks*
[1626] (Edinburgh, 1875), p. 6

16 Letter from Eric Ravilious to
Robert Gibbings, 1927, quoted
in Greenwood 2008, p. 54

17 Breton, *Fantasticks*, p. 10

18 Ullmann, Whittick and
Lawrence 2008, vol. 1, p. 187

19 Ibid., vol. 2, p. 378

20 Robert Macfarlane, *The Old Ways:
A Journey on Foot* (London, 2012),
pp. 296–7

21 Frances Spalding, *The Real and
the Romantic: English Art between
Two World Wars* (London, 2022),
p. 276

22 Ullmann, Whittick and
Lawrence 2008, vol. 1, p. 233

23 Binyon 1983, p. 21

24 J.M. Richards and Eric Ravilious,
High Street (London, 1938), p. 31

25 Powers and Russell 2008, p. 242

26 Letter from Eric Ravilious to
Helen Binyon, September 1939.
Ullmann, Whittick and
Lawrence 2008, vol. 2, p. 496

27 Ullmann 2016, p. 350

28 Douglas Percy Bliss, quoted in
Greenwood 2008, p. 8

29 Greenwood 2008, p. 75

30 Douglas Percy Bliss, 'The Work
of Eric Ravilious', *Artwork*, iv/13
(Spring 1928), p. 64

31 Letter from Eric Ravilious to his
father-in-law, Colonel Garwood,
April 1940. Ullmann 2002, p. 84

32 J.M. Richards recounting a
letter from Edward Bawden,
in Richards 1972, p. 14

33 Letter from Eric Ravilious to
Tirzah Garwood, April 1940.
Ullmann 2002, p. 91

34 Neve 1990, p. 29

Picture Credits

Unless otherwise noted, all works reproduced in this book are in the V&A's collection. The other works are reproduced by kind permission of: Private collection fig. 1, 11, 12, 25, 64, 77, 87; Courtesy of Rosalind and Prudence Bliss, reproduction courtesy of Jeremy Greenwood fig. 2; © the Whitworth, The University of Manchester / photo: Michael Pollard fig. 3, 17, 47; © Fry Art Gallery Society, North West Essex Collection Trust fig. 8, 40; Bridgeman Images / © Fry Art Gallery Society, North West Essex Collection Trust fig. 10, 21, 37, 58, 97; Photo: © The Fine Art Society, London, UK / Bridgeman Images 1; Photo: Birmingham Museums Trust, licensed under CC0 2; © Imperial War Museum (Art.lWM ART LD 1712) 3, (Art.lWM ART LD 5662) 67, (Art.lWM ART LD 17863) 81; © Sheffield Museums Trust 11, 99; Reproduced courtesy of Fiskars 14, 26, 72, 100; Image © Ashmolean Museum, University of Oxford 16; Photo: © Tate. N05402_H 18; Courtesy of The Fine Art Society 19; © Tullie House Museum, Carlisle 20; Private collection / photo: Brian Webb 29; Bridgeman Images / Private Collection 59; Aberdeen City Council (Archives, Gallery & Museums collection) 69; © Royal Academy of Arts, London / photo: John Hammond 92; Leeds Museums and Galleries, UK / Bridgeman Images 98

Acknowledgments

I would like to give thanks to all my current and former colleagues at the V&A who helped me write this book, in particular Gill Saunders and Olivia Horsfall Turner for their feedback on earlier drafts, as well as Julius Bryant, Dan Cox, Doug Dodds, George Eksts, Catriona Gourlay, Christopher Marsden, Jo Norman, and Catrin Jones and Lucy Lead at the V&A Wedgwood Collection. In the V&A Publishing team I would like to thank Karen Fick for guiding a new author so expertly through the process of writing, as well as Hannah Newell and Emma Woodiwiss. Thanks also to the team at Thames & Hudson.

I am grateful to Sara Cooper, James Russell, Anne Ullmann, Peyton Skipwith, Brian Webb, Robin Ravilious, Gordon Cummings, Nigel Weaver, Eleanor Hooker at Lund Humphries, The Fine Art Society, the Fry Gallery, the Towner Gallery and private donors who have been generous in their help with my research and/or have given permission to reproduce images.

Finally, I would like to thank Anne Ullmann for her kindness in reading my drafts, and for her published scholarship on Ravilious and Garwood, which underpins so much of this book.

Selected Bibliography

Author's Biography

Helen Binyon, *Eric Ravilious, Memoir of an Artist* (Cambridge, 1983)

Richard Dennis, *Ravilious and Wedgwood: The Complete Wedgwood Designs of Eric Ravilious* (London, 1986; Shepton Beauchamp, 1995)

Andy Friend, *Ravilious & Co: The Pattern of Friendship* (London, 2018)

Jeremy Greenwood, *Ravilious Engravings* (Woodbridge, 2008)

Robert Harling, *Notes on the Wood-engravings of Eric Ravilious* (London, 1946)

Christopher Neve, *Unquiet Landscape: Places and Ideas in 20th-Century British Painting* (London, 1990, 2020)

Alan Powers, *Eric Ravilious: Imagined Realities* (London, 2003)
———, *Eric Ravilious: Artist and Designer* (Farnham, 2013)
——— and James Russell, *The Story of High Street* (Norwich, 2008)

J.M. Richards, *The Wood Engravings of Eric Ravilious* (London, 1972)

James Russell, *Ravilious in Pictures*, 4 vols (Norwich, 2009–11)
———, *Ravilious* (London, 2015)

Gill Saunders and Malcolm Yorke (eds), *Bawden, Ravilious and the Artists of Great Bardfield* (London, 2015)

Peyton Skipwith and Brian Webb, *Eric Ravilious: Design* (Woodbridge, 2015)

Peyton Skipwith and Brian Webb, *Eric Ravilious Scrapbooks* (Farnham, 2018)

Anne Ullmann (ed.), *Ravilious at War* (Upper Denby, 2002)
——— (ed.), *Long Live Great Bardfield: The Autobiography of Tirzah Garwood* (London, 2016)
———, Christopher Whittick and Simon Lawrence (eds), *Eric Ravilious: Landscape, Letters and Design*, 2 vols (Upper Denby, 2008)

Ella Ravilious is Curator of Architecture and Design at the Victoria and Albert Museum, having worked there in various roles since 2005. She is the granddaughter of Eric Ravilious and Tirzah Garwood. This is her first book.

Front cover image: Detail from *The Long Man of Wilmington*, 1939 (pp. 106–7)
Back cover image: Detail from *The Grape House*, 1936 (p. 57)
Opposite title page: Detail of *Geraniums and Carnations*, 1938 (p. 56)
Opposite contents page: Detail of *Two Cows*, 1936 (p. 95)

First published in the United Kingdom in 2023 by
Thames & Hudson Ltd, 181A High Holborn, London WC1V 7QX
in association with the Victoria and Albert Museum, London

First published in the United States of America in 2023 by
Thames & Hudson Inc., 500 Fifth Avenue, New York, New York 10110

Eric Ravilious: Landscapes & Nature © 2023 Victoria and Albert
Museum, London/Thames & Hudson Ltd, London

Text and V&A photographs © 2023 Victoria and Albert Museum, London
Design © 2023 Thames & Hudson Ltd, London

British Library Cataloguing-in-Publication Data
A catalogue record for this book is available from the British Library

Library of Congress Control Number 2023932264

ISBN 978-0-500-48078-6

Printed and bound in China by C&C Offset Printing Co. Ltd

MIX
Paper | Supporting
responsible forestry
FSC® C008047
www.fsc.org

Be the first to know about our new releases,
exclusive content and author events by visiting
thamesandhudson.com
thamesandhudsonusa.com
thamesandhudson.com.au

V&A Publishing
Supporting the world's leading
museum of art and design,
the Victoria and Albert
Museum, London